Photoshop Elements 9

Prentice Hall
is an imprint of

PEARSON

Harlow, England • London • N long Kong
Tokyo • Seoul • Taipei • New D ris • Milan

PEARSON EDUCATION LIMITED

Edinburgh Gate
Harlow CM20 2JE
Tel: +44 (0)1279 623623
Fax: +44 (0)1279 431059
Website: www.pearsoned.co.uk

First published in Great Britain in 2011

Pearson Education is not responsible for the content of third party internet sites.

ISBN: 978-0-273-74995-0

British Library Cataloguing-in-Publication Data
A catalogue record for this book is available from the British Library

Library of Congress Cataloging-in-Publication Data
Bluttman, Ken.
 Photoshop elements 9 in simple steps / Ken Bluttman.
 p. cm.
 ISBN 978-0-273-74995-0 (pbk.)
 1. Adobe Photoshop elements. 2. Photography--Digital techniques. 3. Computer graphics.
I. Title. II. Title: Adobe Photoshop elements nine in simple steps. III. Title: Adobe Photoshop
elements 9 in simple steps.
 TR267.5.A33B5825 2011
 006.6'96--dc22

 2010046055

10 9 8 7 6 5 4 3 2 1
14 13 12 11 10

Designed by pentacorbig, High Wycombe

Typeset in 11/14 pt ITC Stone Sans by 30
Printed in Great Britain by Scotprint, Haddington.

Adobe ®

Photoshop Elements 9

in Simple steps

Ken Bluttman

Use your computer with confidence

Get to grips with practical computing tasks with minimal time, fuss and bother.

In Simple Steps guides guarantee immediate results. They tell you everything you need to know on a specific application; from the most essential tasks to master, to every activity you'll want to accomplish, through to solving the most common problems you'll encounter.

Helpful features

To build your confidence and help you to get the most out of your computer, practical hints, tips and shortcuts feature on every page:

 ALERT: Explains and provides practical solutions to the most commonly encountered problems

 HOT TIP: Time and effort saving shortcuts

 SEE ALSO: Points you to other related tasks and information

 DID YOU KNOW? Additional features to explore

WHAT DOES THIS MEAN? Jargon and technical terms explained in plain English

Practical. Simple. Fast.

Dedication:

In memory of Chestnut.

Author acknowledgements:

Sincere thanks to Katy Robinson, Steve Temblett, and the great team at Prentice Hall/ Pearson. Neil Salkind and Studio B, as always, the best agent and agency in the land, or rather now I should say across the continents. Thanks to all the creative souls who work with images and imagery. May this book be a help.

Contents at a glance

Top 10 Photoshop Elements Problems Solved

Contents

Top 10 Photoshop Elements Tips

1 Getting your photographs into Photoshop Elements

2 Working with the Organizer

3 Working with the Editor

4 Adjusting colour, contrast and lighting

5 Creating and using selections

6 Cropping, resizing, rotating, flipping and zooming

7 Layers

8 Working with shapes

9 Drawing, patterns and gradients

10 Working with type

11 Enhancing your photographs with blur and sharpen techniques

Top 10 Photoshop Elements Problems Solved

Top 10 Photoshop Elements Tips

Tip 2: Backing up your photographs

It might be mundane but backups are like insurance. You don't need them until... you need them! And if you didn't create any backups it's too late. So, it's good to get the backup habit.

1 In the Organizer, click the File... Backup Catalog to CD, DVD, or Hard Drive menu item. Before the proper dialogue is displayed you may receive a dialogue about missing files. This appears if you moved files around during the current session.

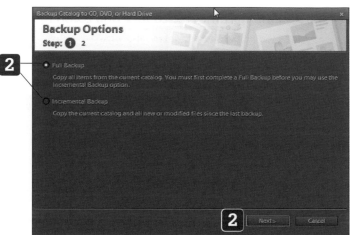

2 The Step 1 Backup dialogue is displayed. In this step you decide on a full backup or an incremental backup. Click Next.

3 In Step 2 select the destination drive and path. Select the drive from the list. Use the Browse feature to select the path. Click the Save Backup button and the backup operation runs.

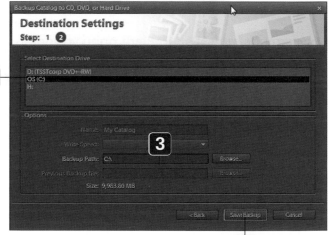

 HOT TIP: An incremental backup looks for and then backs up files that are new or updated since the last backup. If using this option you will be prompted for a destination drive and for the location of the previous backup file.

Tip 3: Assigning a keyword to a photograph

1 In the Organizer, keywords can be dragged onto photographs. While doing so the mouse pointer turns into a hand holding the keyword's icon.

2 Once tagged with a category and possible sub-category, and a keyword, the tagging is listed underneath the photograph.

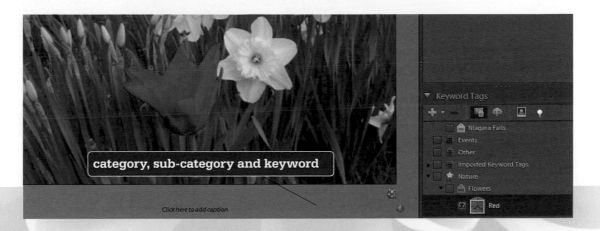

Tip 4: Creating a photo album

1 In the Organizer, in the Albums palette, select the dropdown next to the plus (+) sign and select to create a New Album.

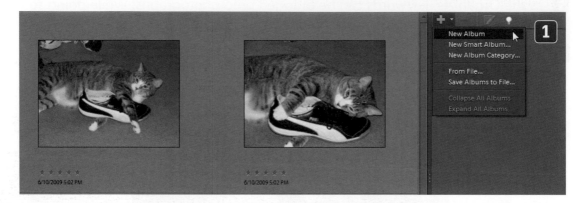

2 Enter the name of the new album. Click Done when finished.

3 The album is created and photographs can be dragged to the album. When this is done, clicking on the album icon displays the photographs that are in the album.

Tip 5: Reversing changes

There is much that literally meets the eye when altering an image and you might not like what you see. Adobe® Photoshop® Elements provides the Undo and Revert commands to reverse changes you have made.

1 Undo: A history of changes is kept, and using Undo back-steps through them as many times as you click Undo. You can click on the Undo arrow to the right of the menus or click the Edit… Undo menu item. Using the menu, the phrase of the menu item will change based on what step is being undone.

2 Revert: This removes all the changes in one click. Whereas the single-step Undo is useful to return to a midpoint in the history of changes, Revert sets the image back to its original state.

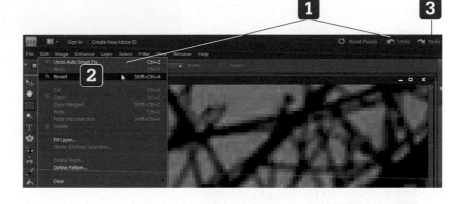

3 Redo: This is the opposite of Undo. Clicking Redo steps forward through the history of changes.

Undo, Redo and Revert are enabled only when there is a history of changes. When a photograph is first opened, none of the options is available. After the first change, Revert and Undo are available. Redo becomes available only after an Undo operation – it would reverse the Undo.

 HOT TIP: After a Revert operation, an Undo Revert becomes available. This puts back all the changes that Revert pulled out. Neat!

Tip 6: Adding to a selection

While a marquee is displayed on an image, you can apply another marquee and make the two join together.

1 Draw the first selection.

2 While holding down the Shift key, draw another selection. Make sure it touches the boundary of the first selection, or even make it start from within the boundary of the first selection.

? **DID YOU KNOW?**
You can do this repeatedly, and can mix and match the rectangular and elliptical marquee shapes.

WHAT DOES THIS MEAN?
Marquee: this is a frame which identifies a selected area of an image. The frame is usually displayed with a flashing, dashed line.

Tip 7: Changing the background to a layer

The effects and changes that can be applied to the background are limited. As you become familiar with what layers offer, you may want to apply these to the background. The trick then is to change the background to a layer.

1 Right-click on the background in the Layers palette. In the context menu select Layer From Background.

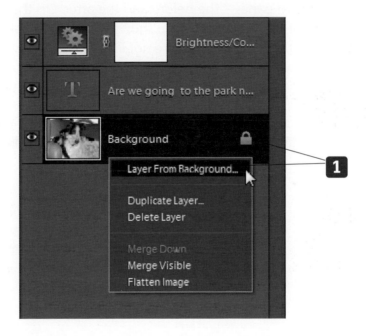

Tip 8: Saving for the web

The number one consideration for images on the web is file size. This applies both to the physical size and the file size in bytes. The physical size matters because the image takes up space on a web page. The file size matters because it affects how fast a web page is loaded. This is not overly important for an image or two. However, if a web page has many images, the page could experience a delay in appearing in a web browser. This usually annoys people.

1 Click the File… Save For Web menu item. The Save For Web dialogue is displayed.

The dialogue has two panes – the before and the after. On the left is the image in its current format, and the right pane shows what it will look like based on selections made in the dialogue. You are not likely to notice much difference in the appearance between the panes. Changes to the image would have already occurred during editing. This dialogue is focused on how to save the image for web page presentation.

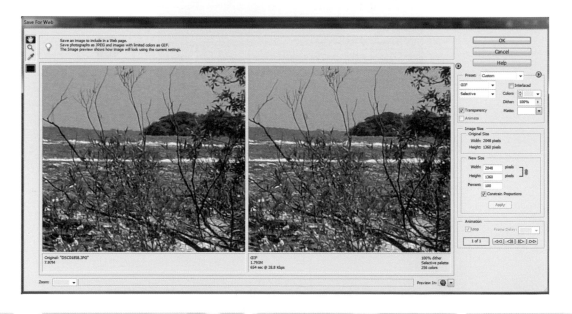

2 Reduce the size of the image and click the Apply button. Select the output file format.

An image for the web should not be exceedingly large. It is not unreasonable to reduce the image by a large percentage. Of course this depends on the original file size. In this example the original size is 2048 × 1360 pixels. This is greater than a standard computer screen. Here, the image is being reduced to a width of 300 pixels. The file format selected is GIF.

3 Click the OK button. The Save Optimized As dialogue opens. This is a typical Save dialogue. Navigate to the folder of your choice and click the Save button.

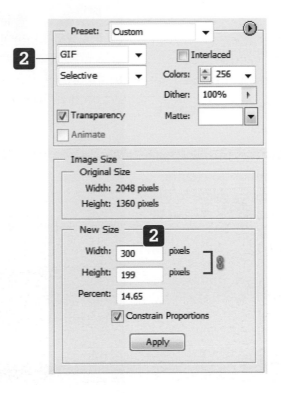

 HOT TIP: Leave the Constrain Proportions tickbox ticked. This ensures that changing any single size attribute – the width, height, or percentage – forces the other attributes to adjust accordingly. Bottom line – the image will retain its appearance, just resized. There will be no squeeze or stretch in the adjustment.

Tip 9: Emailing photographs as attachments

Sending attachments is the alternative to sending embedded photographs. Attachments have a benefit. The recipients can save them in their computer system and view or use them without having to reopen the email message.

1 In the Organizer, click the Share tab.

2 Click the E-mail Attachments button.

3 Drag images from the Organizer into the E-mail Attachments pane.

4 If the images are not in JPEG format, then a tickbox provides the option to change them to JPEG. Other settings relate to the size the photographs should be resized to and the quality of the JPEGs.

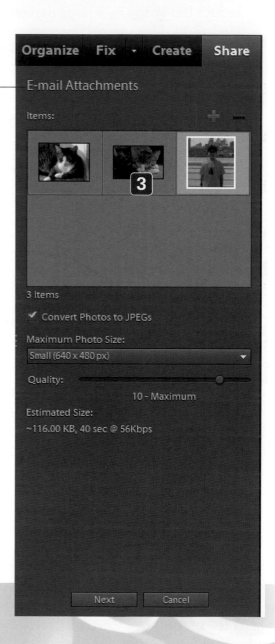

Organize Fix ▾ Create **Share**

2 — E-mail Attachments

Items: ✛

3

3 Items

✓ Convert Photos to JPEGs

Maximum Photo Size:

Small (640 x 480 px) ▾

Quality: ──────────────────●

10 - Maximum

Estimated Size:

~116.00 KB, 40 sec @ 56Kbps

Next Cancel

HOT TIP: If you wish to attach many image files then use the small or very small size. This ensures you won't be sending an enormous-sized email to the recipients.

5 Click the Next button. The following screen is where you select recipients. When finished selecting recipients, click the Next button. An email message is created in your computer's email program and is ready to be sent. The photograph files are attachments to the email.

Tip 10: Setting a photograph as the desktop wallpaper

See a photo you are just in love with? Family, friends, pets, or the moon? Whatever it is, that photograph can easily become the desktop wallpaper on your computer.

1 Right-click on the photograph.

2 Select Set as Desktop Wallpaper.

Yes, it's that simple.

 HOT TIP: You can revert to the previous wallpaper by right-clicking on the desktop and following the prompts to find and select the previous image.

 DID YOU KNOW?

When the image being set as the desktop wallpaper image is small, the single image can be centred on the desktop or it can be tiled to show a repeating pattern. Right-click on the desktop and follow the prompts.

1 Getting your photographs into Photoshop Elements

Introduction

Photoshop Elements serves two general functions: organising photographs and editing photographs. Each of these functional areas has a lot of power to perform the relevant tasks. Before any of this can happen, though, you need to get the photographs into the program!

The Organizer is the half of this dual-purpose program that organises, catalogues, lets you add captions and ratings, and much more. The method for getting photographs in is much more robust in the Organizer. This chapter therefore shows how to gather up your snapshots and bring them into the Organizer. Rather than confuse the issue as to where photographs are actually kept, the terms used here about getting the photographs into the Organizer are a figure of speech. The actual image files themselves do not reside in the program. They reside on the hard disk of your computer, or on a CD/DVD, memory card or anywhere else that files are generally kept. It's their representation and presentation that are handled in the Organizer.

Make sure the Organizer is open. If you are in the Editor, you can click the Organizer button in the upper right part of the screen. Chapters 2 and 3 (about the Organizer and the Editor) show layouts of the respective screens.

Getting photographs from a memory card

The most likely place you will get your photographs from is your camera, of course! The odds are that the files in your camera are actually on a memory card in the camera.

In these steps you will connect your camera or card to your computer. If an automatic file download starts, then enjoy the experience, and afterwards set the preferences for this not to happen next time, if that is what you prefer. (See the *Setting Preferences* section in this chapter.) The following steps are used when the automatic download is not enabled.

1 Connect your camera, or the memory card itself, to your computer – in whichever manner is appropriate for your particular camera, card and computer.

2 Click the File… Get Photos and Videos… From Camera or Card Reader menu item.

3 The Photo Downloader dialogue box opens. Select the source using the Get Photos from dropdown.

4 Select the destination for the photographs by using the Browse feature and making a selection in the Create Subfolder(s) dropdown. If Custom is the choice, then enter a name for the folder underneath the dropdown.

5 The image files being copied into your computer can retain their original names, or you can set up a sequential naming scheme. To do this select Custom Name from the Rename Files dropdown. Enter a name in the box underneath and a starting number. As an example, if Chess is entered as the custom name, the files will be renamed to Chess_0001, Chess_0002, and so on.

 HOT TIP: When selecting Create Subfolder(s), avoid using any of the Short Date options. A folder named as a date is not intuitive for indicating what files are in the folder.

6 If desired you can instruct Photoshop Elements to delete the files from the card after they have been imported to the computer. To do this, select the After Copying, Delete Originals option from the Delete Options dropdown. Otherwise leave the setting at After Copying, Do Not Delete Originals.

7 Click the Get Media button.

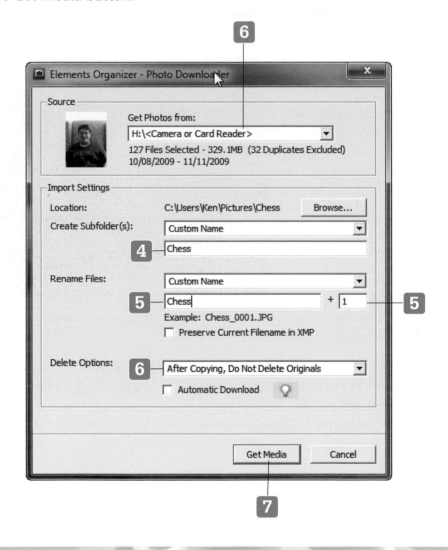

Getting photographs from a scanner

Do you have great artwork that is not in a file? Have a scanner? You can easily run the scanning and file saving direct from Photoshop Elements.

1 Click the File… Get Photos and Videos… From Scanner menu item. The Get Photos from Scanner dialogue box is displayed.

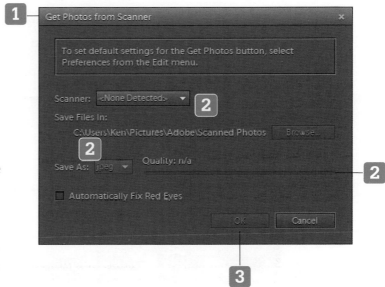

2 Select the scanner from the dropdown. Browse to select the folder where the scanned image will be saved. Select the Save As file type (jpeg, tiff, or png). If a jpeg file type is selected, you can use the slider to set the quality.

3 Click the OK button. The software that runs the scanner will start up. After the scan is complete and the scanner software is closed, the file will be in the selected folder and will also be found in the Organizer.

 DID YOU KNOW?
With the jpeg file type, the higher the quality, the larger the file size. The only reason to consider anything less than the best quality is if the file will be used on a web page or sent via email. In such cases file size matters.

HOT TIP: If your scanner is not found in the dialogue it probably means you have to load the driver software for the scanner. Check the scanner manual.

Getting photographs from a folder

It's quite possible that image files are already in your computer but not found in the Organizer. In this case the files are not being copied but will be represented in the Organizer, which of course lets you do all types of fun things, as you will see in Chapter 2.

1 Click the File… Get Photos and Videos… From Files and Folders menu item. The Get Photos and Videos from Files and Folders dialogue box is displayed.

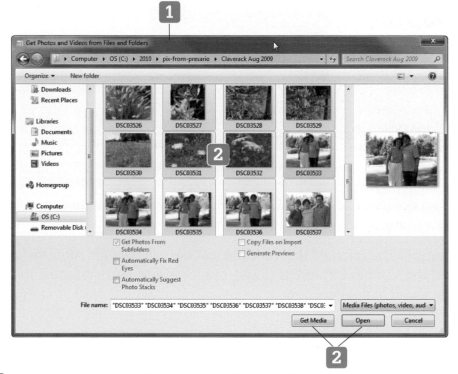

2 Browse to the desired folder and select the files you want. Then click either the Open or the Get Media button.

HOT TIP: You select more than one file by holding down the Ctrl key while clicking on file names.

The Photo Downloader

The Photo Downloader is the powerful 'get all the media from wherever it might be' utility. On the following page you will see where to set preferences to have the Photo Downloader run automatically. You may decide to turn this feature off, but if left on then here is what you do.

1 Insert the memory card or attach the camera to the computer. The Photo Downloader starts copying photographs to the computer. The destination folders are based on how they were selected in a prior session using Photoshop Elements.

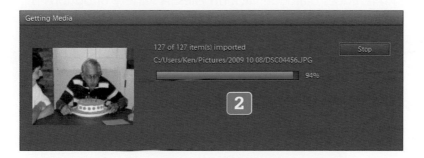

2 Watch the import process if you wish. There is nothing else you need to do. However, you can stop the process if necessary. While the Photo Downloader is running a progress window is displayed, on which is a Stop button.

 HOT TIP: If you know how to delete unwanted single images in your camera, do so first. This saves having to delete them in Photoshop Elements.

Setting Preferences

There are several facets of Photoshop Elements that you can set to desired default properties or actions. Some of these involve the copying of image files.

1 Click the Edit… Preferences… General menu item to display the Preferences dialogue. The initial view is the General preferences.

In the General preferences you can select to work in inches or metric measurements, choose the date format, and a few other settings.

2 In the left side of the Preferences dialogue click on Files. A variety of options is available relating to how and where files are saved.

3 In the left side of the Preferences dialogue click on Camera or Card Reader. Here is where you select the useful Automatically Fix Red Eyes option. Here too is the option to have the Photo Downloader start when a memory card or camera is attached to the computer.

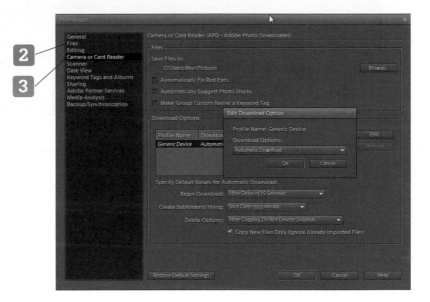

Along with the start option are the choices for how to create folders to hold incoming files.

HOT TIP: You should consider whether or not to disable the automatic downloading. While this is a great feature – just hook and go – it can also be annoying.

Moving files

You can move files from one location to another from within the Organizer.

1 Select one (click on the photograph) or more photographs to move (holding down the Ctrl key, click on multiple photographs).

2 Click on the File… Move menu item to display the Move Selected Items dialogue box.

3 Use the Browse feature to select a destination folder.

4 Click OK to close the Browse For Folder dialogue. Then click OK to close the Move Selected Items dialogue. The files are moved to the new folder.

Backing up your photographs

It might be mundane but backups are like insurance – you don't need them until… you need them! And if you didn't create any backups it's too late. So, it's good to get the backup habit.

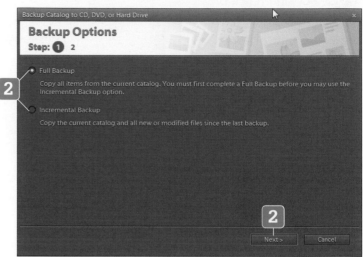

1 Click the File… Backup Catalog to CD, DVD, or Hard Drive menu item. Before the proper dialogue is displayed you may receive a dialogue about missing files. This appears if you moved files around during the current session.

2 The Step 1 Backup dialogue is displayed. In this step you decide on a full backup or an incremental backup. Click Next.

3 In Step 2 select the destination drive and path. Select the drive from the list. Use the Browse feature to select the path. Click the Save Backup button and the backup operation runs.

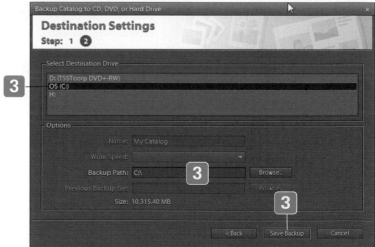

HOT TIP: An incremental backup looks for and then backs up files that are new or updated since the last backup. If using this option you will be prompted for a destination drive and for the location of the previous backup file.

2 Working with the Organizer

Introduction

With the ability to take and store hundreds or thousands of pictures comes the need for ways to organise them. Photoshop Elements provides this capability with the Organizer. Photoshop Elements is basically a dual application: the storing and organisation of artwork, and the creation and editing of artwork. The latter is done within the Editor, which is described in several later chapters.

The Organizer, though, is what you will use to categorise your artwork. Besides divvying up photographs into categories, you can add captions and keywords, rate them with a 0–5 stars system, and more. You can even associate a photograph with a place on the globe by using the provided map feature. To help you follow the steps, a full screen shot of the Organizer is shown here with a key to major areas:

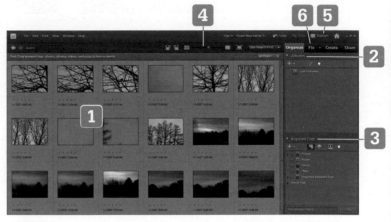

1. Photo Browser

2. Albums palette

3. Keyword Tags palette

4. Thumbnail size slider

5. Display options

6. Go to the Editor (used throughout later chapters).

Adjusting the thumbnail view

The Organizer displays thumbnails of your photographs. The thumbnail size is controlled by a slider near the top of the Organizer. By adjusting this you can have the Organizer display anything from a single large thumbnail image to dozens of smaller thumbnails.

1 Using the mouse, move the slider to the left to show many small thumbnails, or move the slider to the right to show fewer but larger thumbnails, up to displaying just one large thumbnail.

2 With the slider all the way to the left, many small thumbnail images are shown.

3 Putting the slider all the way to the right displays a single large thumbnail image.

Even with a single large thumbnail in view, you can scroll through the images using the scroll on the right side of the viewing area.

 DID YOU KNOW?

To the left of the slider is a group of four small blue boxes. Clicking on this group will instantly change the view to display small multiple thumbnails. To the right of the slider is a single blue box, that when clicked instantly changes the view to a single large thumbnail.

Sorting thumbnails

With many thumbnails displayed in the viewing area of the Organizer, it's helpful to sort them. You can sort the images by date, either from newest to oldest or from oldest to newest.

1 To the right of the thumbnail view slider is a dropdown with the two options of how to sort by date.

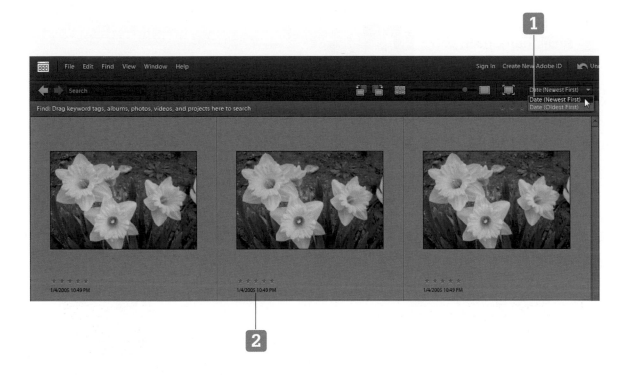

2 Each image has an associated Date Stamp. This is the date used for the sort. The date is part of the metadata stored with the image file.

Adding a caption to a photograph

A caption can be assigned to a photograph. This does not change the file name. The caption becomes a part of the photograph's metadata.

1 Right-click on an image to display the context menu.

2 From the context menu, select Add Caption.

3 Enter a caption and click OK to save it.

3

HOT TIP: You won't see the caption unless the display is set to show the single thumbnail in the viewing area. Then the caption is seen underneath the image.

Creating a category

Categories provide a way to associate photographs that are similar in some respect. For example, a category named Animals could associate all the photographs you took at the zoo last year, or a category named Bahamas vacation for, well… you get the idea. Here is what you do:

1 In the Keyword Tags palette, click the arrow to the right of the green plus (+) sign, to open a context menu.

2 Enter a name for the category and select an icon.

? DID YOU KNOW?
You can also click the Choose Color button. This displays a colour picker from which you select the colour for the icon's appearance.

Creating a sub-category

Any created category can have sub-categories. A category named Nature could have a sub-category named Flowers. A category named Family could have several sub-categories – one for each family member.

1 First right-click on the category for which a sub-category is being created. A context menu appears. Select Create new sub-category in (name of category) category.

2 The Create Sub-Category box appears. Enter the name of the sub-category and click OK. The Keyword Tags palette shows the categories and sub-categories.

In this example the category Nature has the Flowers sub-category.

HOT TIP: If you decide the sub-category should go under a different parent category, right-click on the sub-category, select Edit in the context menu, and select a different parent category.

Adding a photograph to a category or sub-category

Now that you have categories and possible sub-categories, the task at hand is to associate photographs with the categories and sub-categories. This is easily done by dragging photographs and dropping them directly onto the category or sub-category. In fact, the dragging and dropping can go in either direction: you can drag one or more photographs onto a category or sub-category, or you can drag the category or sub-category onto a photograph.

1 Select one or more photographs. Here, three photographs of Niagara Falls are selected (they have a white border – indicating they are selected).

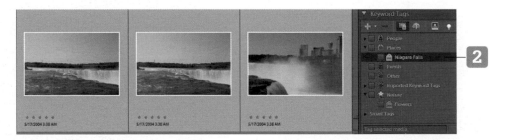

2 Click and hold down the mouse button. Drag the photographs over to the category or sub-category. While doing this operation the mouse pointer looks like a hand holding a stack of photographs. The three photographs now display the icon of the Niagara Falls sub-category.

? DID YOU KNOW?

If you select multiple photographs prior to dragging the category over, then all the selected photographs will become associated with the category.

Creating a keyword

Keywords are similar to categories and sub-categories. In fact, as you probably noticed, categories and sub-categories have been created inside the Keyword Tags palette. Keywords must belong to a category or sub-category. An advantage in associating photographs with keywords is the ability to search on keywords.

1 Right-click on either a category or sub-category and select it to create a new keyword. A dialogue box appears in which you enter the name of the keyword. You can also edit the keyword's icon.

The keyword name belongs to the category or sub-category.

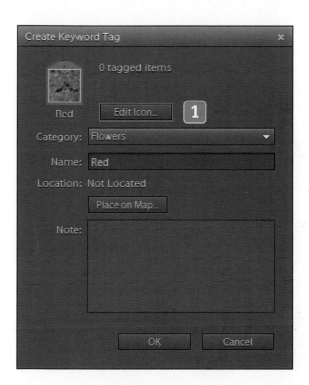

? DID YOU KNOW?

The same keyword(s) can be used in more than one category.

Searching for photographs

Just above the thumbnails, on the left side of the Organizer, is the Find area where various items can be dragged to facilitate a search. Keyword icons and category/sub-category icons can be dragged here. A useful attribute of this type of searching is the ability to mix different keywords and/or categories. This example does just that.

1 The Family sub-category icon is dragged to the Find area. This is done by clicking on the icon and holding down the mouse button while dragging the icon to the Find area. Then, letting go of the icon updates the display to show just photographs tagged with the Family sub-category.

2 Another sub-category, Flowers, is dragged to the Find area. The display now shows photographs tagged as Family or Flowers (or both of course!).

3 An additional search feature is pulled into the mix. This is the Date Range selector. This dialogue box is displayed by using the Find… Set Date Range menu. Using it to limit photographs to those dated as 2007 and 2008 only reduces the number of displayed photographs.

? DID YOU KNOW?
Under the Find menu are other methods for finding photographs, such as by caption or file name.

Using the Timeline to find photographs

The Timeline provides a fast way to zero in on photographs taken on a given date or a range of dates. The Timeline works a bit like a chart. Along the horizontal bottom of the Timeline are date markers, and above them are columns that are as tall as the number of photographs attached to the date. (Think of this as a simple bar chart that you may have come across in school maths lessons.)

1 Use the Window… Timeline menu to display the Timeline.

2 The Timeline has a small selector window that is dragged across the Timeline and determines the photographs, by date, that will be displayed in the Photo Browser. On each end of the Timeline are margin markers that limit how far the selector window can travel back and forth. Along the Timeline are bars, at

certain 'places in time', determined by the photographs. The more photographs at a given date, the higher the bar will be, and therefore more photographs will be displayed.

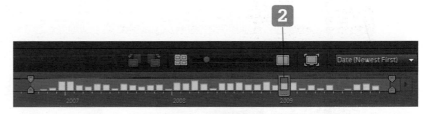

 HOT TIP: If you are looking for a photograph from a certain year or month, move the left and right markers close to the start and end dates of that year or month.

Using Date View to find photographs

A very useful date-based search utility is the Date View. The Date View is a calendar-based interface that shows which days have photographs that are dated as such. As with any sophisticated calendar, you can change the view between year, month or day, and you can scroll through any of these date delineations.

1 Use the Display options dropdown to select the Date View for display.

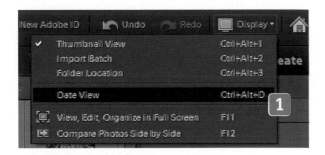

2 Select the type of display you desire – year, month or day – and then scroll to the year, month or day you wish to look at. Here is a month view that shows some days have photographs dated to the particular day. Where the day is empty, no photographs in the Photo Browser have a creation date that matches.

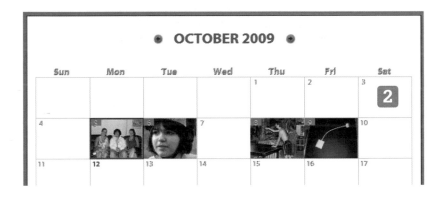

 HOT TIP: At the bottom of the display is a button to click to return to the full Photo Browser, or you can use the Display options dropdown again to select Photo Browser (which reverts from Date View).

Creating an album

An album is another tool for getting your photographs organised. An album is similar to a category in that you set desired photographs to be brought together based on some commonality.

1 In the Album palette, select the dropdown next to the plus (+) sign and select to create a New Album.

2 Enter the name of the new album. Click Done when finished.

3 The album is created and photographs can be dragged to it. When this is done, clicking on the album icon displays the photographs that are contained in that album.

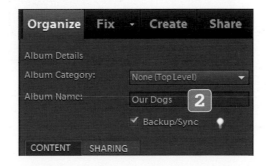

 HOT TIP: Click on the album icon again to have the Photo Browser return to displaying all photographs.

Creating a Smart Album

Another way to create an album is to use the Smart Album feature. This lets you create an album by running a search through all the photographs in the Photo Browser and having those that meet the criteria you stipulate become photographs that belong to the album.

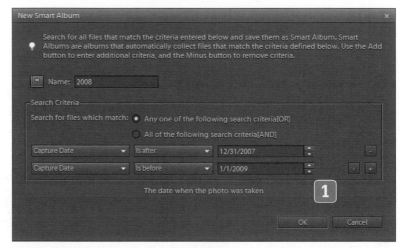

1 In the dropdown next to the plus sign (+) in the Album palette, select to create a New Smart Album. In this example an album titled 2008 will contain all photographs that are dated after December 31 2007 and before January 1 2009.

2 The 2008 album is created and populated with all the photographs that match the criteria.

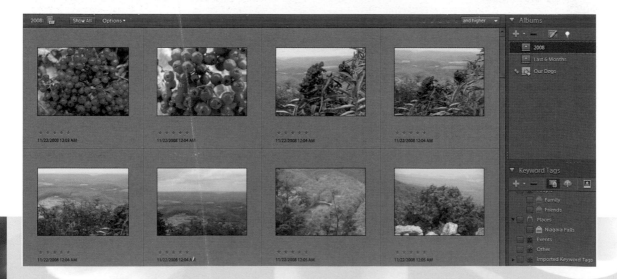

Using Folder Location view

Folder view is another method of arranging photographs in the Photo Browser. Viewing by folder makes it easy to track down photographs that exist within known folders. Although there are many photographs in the Photo Browser, the files actually reside wherever they can in your computer system.

Folder location provides two views by folder. On the left of the Photo Browser is an expandable/collapsible hierarchical list of folders in your computer. In the main area of the Photo Browser are the photographs, only now separated by folder.

1 Select Folder Location from the Display options dropdown. To revert to the normal Photo Browser view, use Display options again and select Thumbnail view.

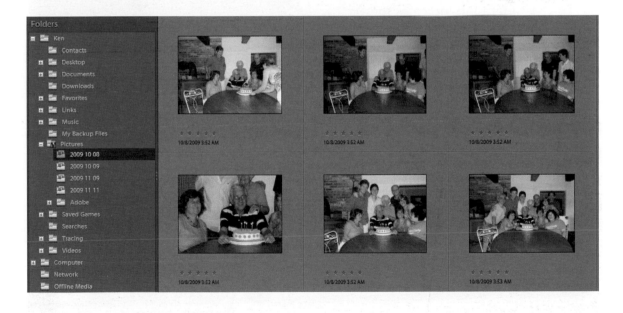

Displaying properties

There is a wealth of information incorporated into your digital photographs. General information, keyword tags, history data and metadata are available to view by displaying the properties of a photograph.

1 Right-click on a photograph and select Show Properties from the context menu. The Properties window has four symbols: clicking each shows a tab of available information. The first Properties view displays the General settings.

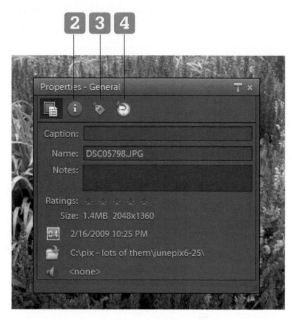

2 The Metadata tab indicates the photograph's conditions: the exposure time, F-stop, whether the flash fired, and more. There are two ways to view metadata – brief and complete. This choice is made at the bottom of the Properties window.

3 The Keyword Tags tab displays any categories and/or keywords.

4 The last tab – History – displays just a brief bit of information about modified and imported dates.

 DID YOU KNOW?

The exposure time is the amount of time the camera shutter stayed open when taking the photograph. A longer amount of open time allows more light in, but can introduce blurriness if the camera isn't held rock steady (or put on a tripod). The F-stop is the size of the shutter opening (which can change). Varying F-stop values and exposure times creates a world of possibilities.

 HOT TIP: You can leave the Properties window open and click on different photographs. The Properties window will display the properties of the selected photograph.

Deleting a photograph

A photograph can be removed from the Photo Browser. It is up to you whether you delete it altogether from your computer.

1 Right-click on the photograph you wish to delete. Select Delete from Catalog from the context menu. The Catalog is the collection of photographs in the Photo Browser.

2 The Confirm Deletion from Catalog dialogue appears. There is an optional tick box that also allows you to delete the photograph from the hard drive of your computer. Use that option with care.

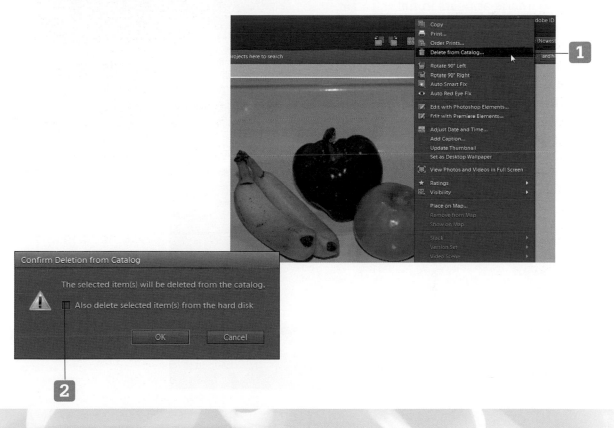

HOT TIP: As long as you did not remove the photograph from the hard drive, then you can easily bring it back by using the File... Get Photos and Videos menu.

Viewing a photograph in Full Screen

In the Organizer is a button that when clicked presents the currently selected photograph in full screen mode – that means it will occupy the full area of your computer monitor. This can be quite striking!

1 Click the Full Screen button located along the top of the Organizer.

2 The image appears in full screen. Some optional dialogues can be used, such as for quick editing. There are other options to cycle through photographs or to watch the photographs as a slide show.

 HOT TIP: When running through your photographs as a slide show, you can select how the photographs transition as they change.

3 Working with the Editor

Introduction

In the previous chapter you learned how to organise and categorise photographs. Additionally, keywords, albums, captions and other information were put to use. In this chapter, and in all those after it, you will learn how to edit or change facets of photographs. This is the real meat and potatoes of Photoshop Elements.

All photo manipulation is done within the Editor – the part of Photoshop Elements that provides all the tools needed to alter and enhance your works of art. Knowing the various areas of the Editor is key to using it effectively. This chapter introduces the Editor screen and how to work the Editor to bring your creative ideas to fruition. First, a full screen shot of the Editor is shown here with a key to the major areas.

1. Active image area
2. Project Bin
3. Layers
4. Palettes
5. Palette Selector
6. Toolbox
7. Tool options
8. Display the Organizer
9. Edit options

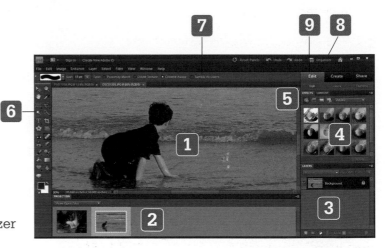

Adding a photograph to the Project Bin

It is possible, and often useful, to have more than one photograph image open in the Editor. Why? You might be combining parts of different images (a collage), sampling a colour from one photograph to use in editing another or any other numerous reasons.

The Project Bin, at the bottom of the Editor, displays thumbnails of each open photograph. To open the first photograph or an additional photograph:

1 Use the File… Open menu to select a photograph to open. The Open dialogue is displayed and a photograph can be browsed to and selected to open.

2 The photograph joins others in the Project Bin. It also is displayed as the active image.

To remove a photograph, right-click on the image in the Project Bin and select Close from the context menu.

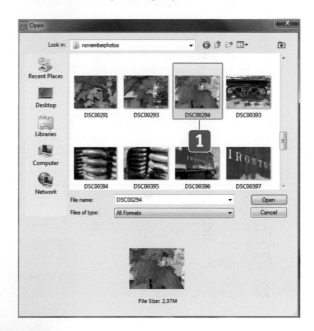

HOT TIP: Other options in the File menu provide other ways to bring photographs into the Editor. You can select a file from the Recently Edited Files list or import a frame from a video file.

Displaying multiple photographs

When more than one photograph file is opened there are numerous thumbnails displayed in the Project Bin. You can bring them all into the active image area as tiled or cascaded images.

1 Use the Window… Images… Tile menu to display tiles of the images.

2 To display the images in a cascade, use the Window… Images… Cascade selection.

3 For full control of how many photographs to display in the Active Image Area, use the minimise, maximise and resize controls in the upper right of any or all of the images. This way you can individually move the photographs in any manner you desire, such as putting two photographs next to each other.

Selecting a tool from the Toolbox

The Toolbox contains many of the items you need to work with your images. One tool is selected at a time.

1 Click on the desired tool in the Toolbox. The tool is activated and ready to be used. When a tool is selected, the Tool Options change accordingly to offer the options available for the selected tool.

 HOT TIP: Once a tool is selected it remains active until you select another tool. Most tools change photographs in some aspect, so to be on the safe side, when done with the altering tool, select a passive tool such as the Hand or Move tool.

Selecting a palette

In the Palettes area are selections for four types of palettes:

- Filters

- Layers

- Photo effects

- All – this makes all the palette choices available.

Within each palette type are sub-selections. These are found in the dropdown to the right of the Palette Selector. (When All is selected the dropdown is not visible, as all options are displayed as thumbnails in the palette.)

1 Select a palette. The items in the dropdown change to match the palette selection.

SEE ALSO: Applying the effects and other stylisations are explored in greater detail in later chapters.

Using Quick Editing

1 On the Edit tab click the Quick button. The palettes are replaced with a series of slider controls, organised by type of editing: Lighting, Color, etc.

2 Try out different settings with the slider controls. The effects are instantly seen in the image. A tick mark icon and a cancel icon appear when a change is made. You can then commit (click the tick mark) or drop (the cancel icon) the changes. Notice also that the number of tools in the toolbox is reduced.

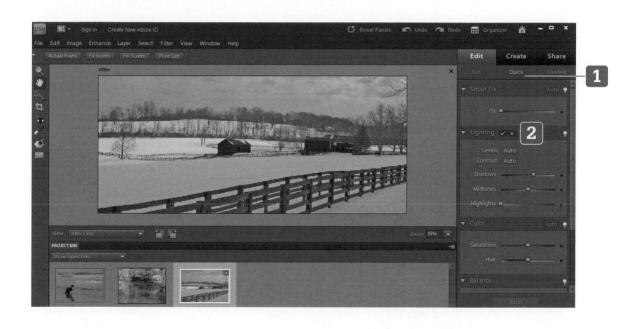

? DID YOU KNOW?

Quick Edit mode gives you the best of both worlds. In Quick Edit mode you control the essential editing properties and Photoshop Elements keeps the rest out of your hair.

Using Guided Editing

Guided Editing is the easiest editing mode as Photoshop Elements walks you through the steps.

1 On the Edit tab click the Guided button. Note that the Toolbox is empty except for the passive tools – the Zoom tool and the Hand tool, along with the foreground and background colour selectors.

2 Click on an item in the Guided Editing list. Photoshop Elements will take you step by step to achieve the editing focus you selected.

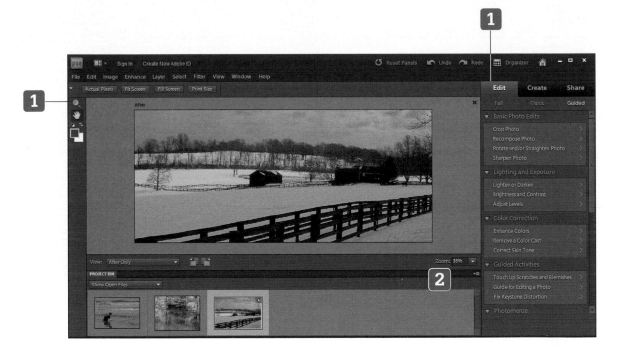

4 Adjusting colour, contrast and lighting

Introduction

Colour is an essential part of any image. Colour appearance though is comprised of more than just the colour itself. The contrast and lighting applied in an image affect colour. Contrast affects how strong or washed out colours may look. Lighting alters colours as well: if a picture is made lighter then all the colour in it will appear lighter as well. Yet changing lighting may change contrast, so coordinating these various aspects really is an art.

Photoshop Elements provides a wealth of tools and methods to manipulate colour, contrast and lighting. The appearance of colours can be altered slightly in just those areas that need a 'touch-up' or as drastically as reversing all the colours in an image.

Briefly, there are the three primary colours – red, green and blue. These are 'additive' primaries: adding them together produces an increasingly light colour. With fully applied red, green and blue the resultant colour is white. Removal of all three primary additives results in black or, in other words, the absence of any colour. The acronym RGB, used in computer application colour settings, literally means Red, Green, Blue, and these three colours are each set anywhere between 0 and 255 inclusive (256 options of each). This produces a range of more than 16 million colours.

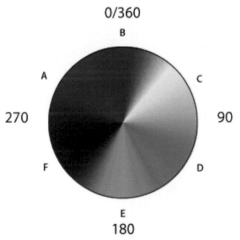

A second set of primaries is 'subtractive' colours: cyan, magenta and yellow. These are also referred to as the secondary colours. The additive and subtractive primaries are best understood by looking at the colour wheel. In the colour wheel, each additive is set opposite its complementary subtractive. Red faces cyan, green faces magenta, and blue faces yellow. In practice, the increase or decrease of an additive causes the decrease or increase of its complement.

For example, reducing blue increases yellow; reducing yellow increases blue.

In the image of the colour wheel:

A is magenta

B is red

C is yellow

D is green

E is cyan

F is blue.

Knowing how additives and subtractives work is not strictly required to use Photoshop Elements. Being aware of the interplay of colours, however, will help you understand how colours are altered and how to approach their alteration. For example, applying a magenta filter will reduce green to a great degree; applying a cyan filter will also alter green but to a lesser degree.

The RGB approach is centric to a computer and equipment. An alternative approach to colour settings, HSB (Hue, Saturation, Brightness), is considered the more 'human' paradigm. Hue is colour and saturation is the strength of the colour. Hue is measured on a 0–360 scale, which represents a place on the colour wheel. Saturation is measured from 0% to 100%. At 0% saturation, an image is greyscale – no colour is present. Finally, brightness (or lightness) is a measure which runs from total darkness at 0% to full brightness at 100%. At the minimum, an image is completely black; at the maximum it's completely white.

Using Auto Color Correction

Photoshop Elements provides many automatic types of image correction or alteration and these are very handy. You just select the action or method you want and Photoshop Elements does the rest! Here, the colour is altered in just a mouse click to what an internal algorithm concludes is best.

1 Click the Enhance… Auto Color Correction menu item.

2 The photograph is corrected according to built-in methods. In this example the colours appear brighter and fuller.

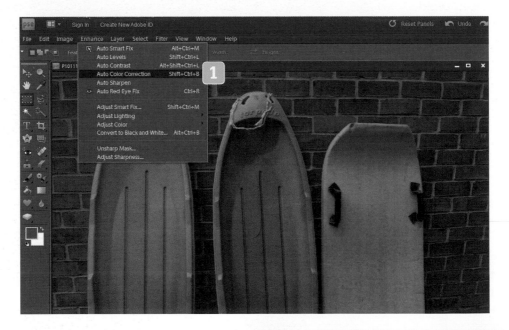

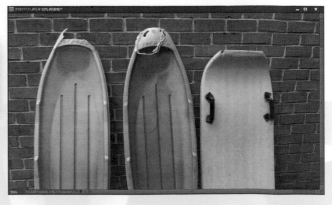

 HOT TIP: If an area of an image has been 'selected', the correction will be applied to just the selected area.

 SEE ALSO: Creating and using selections is covered in Chapter 5.

Using Auto Contrast

Contrast is used to alter how distinct the different portions of an image are to each other, such as between light and dark areas. Contrast is useful in adding life to a dull-looking image. Auto Contrast instructs Photoshop Elements to alter the contrast automatically.

1 Click the Enhance…
Auto Contrast menu
item.

2 Contrast is applied
and the photograph
looks lively. In this
example the clouds
are more prominent
against the sky.

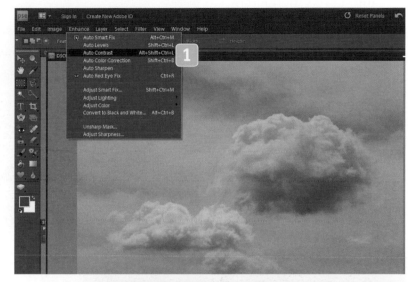

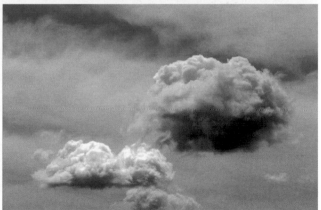

 HOT TIP: If the Auto Contrast feature does not produce a pleasing result, use the manual contrast setting in the Enhance… Adjust Lighting… Brightness/ Contrast menu.

Using Auto Levels

Level is a measure of luminance or brightness. Auto Levels correction will balance the level of a photograph, based on the range of level found in the image.

1 Click the Enhance… Auto Levels menu item.

2 The brightness is changed. In this example the image has been made brighter.

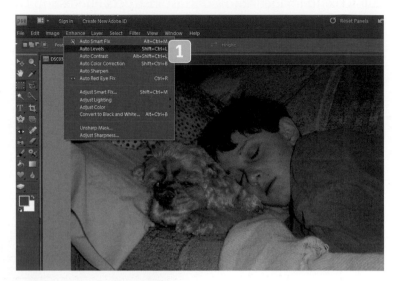

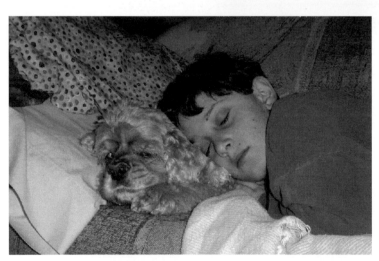

Using Auto Smart Fix

Auto Smart Fix applies the colour, contrast and level corrections all in one operation.

1 Click the Enhance… Auto Smart Fix menu item.

 HOT TIP: Using Auto Smart Fix takes care of all corrections in a single mouse click!

Reversing changes

There is much that literally meets the eye when altering an image and you might not like what you see. Photoshop Elements provides the Undo and Revert commands to reverse changes you have made.

1 Undo: A history of changes is kept and using Undo back-steps through them as many times as you click Undo. You can click on the Undo arrow to the right of the menus or click the Edit… Undo menu item. Using the menu, the phrase of the menu item will change based on what step is being undone.

2 Revert: This removes all the changes in one click. Whereas the single step Undo is useful to return to a midpoint in the history of changes, Revert sets the image back to its original state.

3 Redo: This is the opposite of Undo. Clicking Redo steps forward through the history of changes.

Undo, Redo and Revert are enabled only when there is a history of changes. When a photograph is first opened, none of the options is available. After the first change, Revert and Undo are available. Redo becomes available only after an Undo operation – it would reverse the Undo.

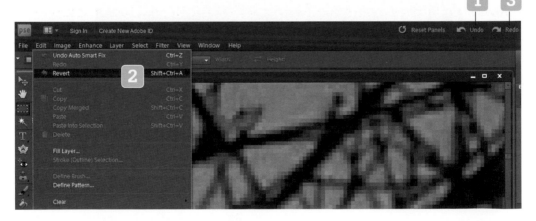

HOT TIP: After a Revert operation, an Undo Revert becomes available. This puts back all the changes that Revert pulled out. Neat!

Selecting the Color Settings

The colour setting tells Photoshop Elements how to treat colours with regard to where they are being viewed: on the computer screen or on paper. For most purposes you will want the setting to be optimised for the computer screen.

1 Click the Edit... Color Settings menu item to display the Color Settings dialogue box.

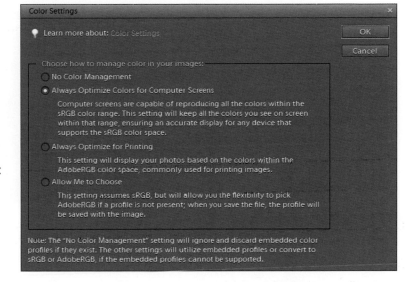

There are four options:

- No Color Management: The colours appear as they truly are in the image file.

- Always Optimize Colors for Computer Screens: This is the best all-purpose choice.

- Always Optimize for Printing: This setting is best if you print many of your photographs. This setting involves using colour profiles for different types of equipment (cameras, printers, etc.). This is an advanced feature that can be ignored since Photoshop Elements provides a default colour profile.

- Allow Me to Choose: This setting involves using colour profiles for different types of equipment (cameras, printers, etc.). This is an advanced feature that can be ignored since Photoshop Elements provides a default colour profile.

 HOT TIP: Always Optimize Colors for Computer Screens is the best selection for images edited for the web.

Working with different image modes

The image mode sets the foundation for the work you will do with colour.

1 Click on the Image... Mode menu item. The choices of mode are available as sub-menu items.

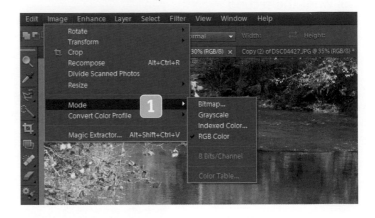

- Bitmap: In bitmap mode images are comprised of black and white pixels. Only two resolutions are available: 72 ppi (pixels per inch – for web work) or 300 dpi (dots per inch – for print work). This provides some limited but interesting effects; however, all is still in black and white (with no greyscale to blend black and white).

- Grayscale: This displays images in 256 levels of grey. This is a good way to leave out the colour but retain contrast.

- Indexed Color: This is a setting used primarily for the web. This provides up to 256 colours. Layers are not supported (see Chapter 7 on layers).

- RGB Color: This is the default colour mode. Over 16 million colours are available, providing the richest work environment.

HOT TIP: Working in Grayscale can produce stark but stunning images, especially with images that contain significant contrast of light and dark areas.

Adjusting Brightness and Contrast

The overall brightness and overall contrast of an image are changed via two slider controls.

1 Click the Enhance… Adjust Lighting… Brightness/Contrast menu item. The Brightness/Contrast dialogue box is displayed.

2 The initial value for both brightness and contrast is zero, with the sliders set at the midpoint. Adjusting the image using the sliders provides more or less brightness or contrast, relative to the level of brightness or contrast in the image to begin with. Therefore there are no fixed values to enter or slide to, but any value selected is an offset for that particular image. So what has been brightened in one image may still be darker than the average state of another image.

> **▶ SEE ALSO:** Adjusting the brightness and contrast or adjusting the lightness (see page 62) can produce similar results.

Adjusting Hue, Saturation and Lightness

1 Clicking the Enhance… Adjust Color… Adjust Hue/Saturation menu item, or using the Ctrl+U keyboard shortcut (in Windows), displays the Hue/Saturation dialogue box.

2 This dialogue is used to alter components of the HSB model. Each individual component alters the image in a different way:

- Hue – adjusts the colour spectrum in the photograph.

- Saturation – adjusts the level of colour. The lowest setting removes all colour, leaving a greyscale image.

- Lightness (brightness) – adjusts how dark or light the image will be. At the lowest setting the image is completely black. At the highest setting the image is completely white.

3 When initially displayed the hue, saturation and lightness values are all set to 0. Also, the choice of which colour(s) to edit is set to Master – which is the complete range of colours in the image.

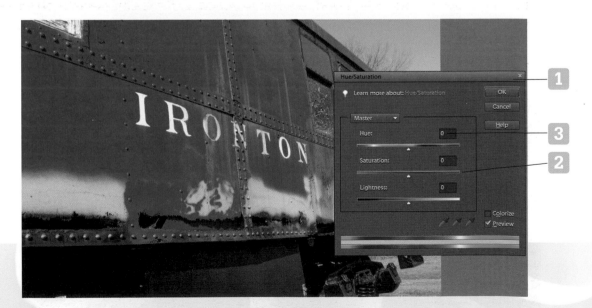

4 Changing the settings alters the image. The changes affect the complete colour spectrum since the Edit dropdown is on Master.

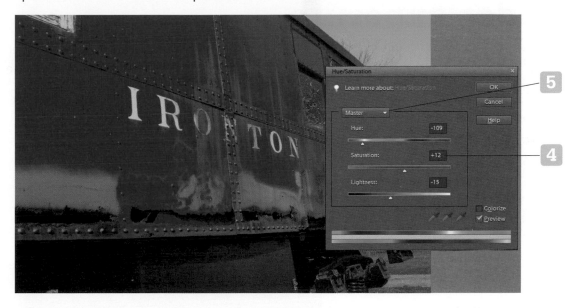

5 In the Edit dropdown, besides Master, are choices for additive and subtractive primary colours.

6 Selecting Yellows in the Edit dropdown and lowering all three components changes the gold-looking rust part of the caboose to a shade of grey. Note that only yellow is affected. Therefore although the Lightness setting is approaching its minimum value, the overall image stays intact.

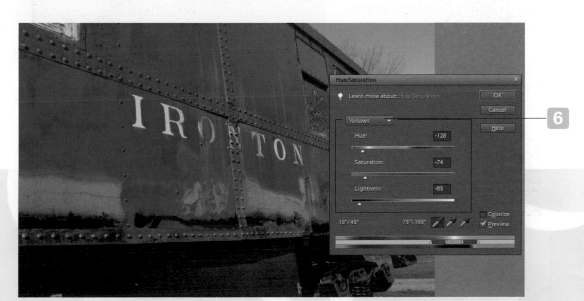

Correcting over- and under-exposure

Shooting photographs is a complex undertaking. You, as the picture taker, decide what or whom the subject is, how close or far to be, which direction to face, and so on. The camera, if on an auto setting, handles shutter speed, shutter size and whether flash is used. On manual settings you make some or all of those decisions. In a nutshell, a lot goes on when the picture is snapped, and the photograph may not turn out to be at all what you thought it would be.

One area that is prone to being out of kilter is the brightness (exposure) of the picture. Whereas brightness can be altered with the Hue/Saturation/Lightness settings, there is another approach that provides more options to correcting the exposure. This is handled by altering shadows, highlights and the tone.

Here is a photograph of a friendly reptile looking with excitement at his supper (peach baby food!). The photograph is under-exposed, it is too dark.

To improve the exposure the shadows, highlights and midtones can be altered.

1 Click the Enhance… Adjust Lighting… Shadows/
 Highlights menu item to display the Shadows/Highlights dialogue box.

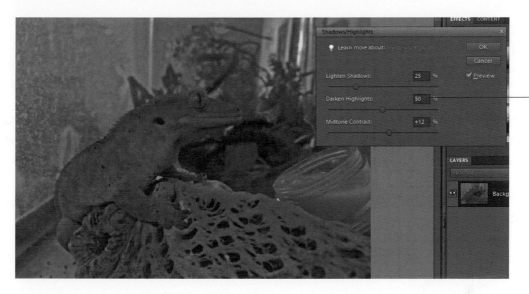

2 Experiment with various combinations of the shadows, highlights and midtone settings:

- Lighten Shadows – brightens dark areas.

- Darken Highlights – darkens light areas.

These two choices may seem to cancel each other out, but not quite. Lighten Shadows applies brightening to shadowed areas. Darken Highlights works on highlights, the opposite of shadows. So in effect these settings are complementary.

- Midtone Contrast – affects the amount of contrast in the middle tones of the image, but not the image overall.

There is no magic 'fix it all' for these settings. Each image will make best use of its own mix of the settings. Here, the lizard is brighter and there is an increase in contrast. Considering it's a brown lizard on a brown stick the added contrast to midtones is useful. The bowl of baby food looks as appetising as ever.

SEE ALSO: Adjusting overall brightness and contrast can help with under-exposure – see page 61.

Adjusting shadows, highlights and midtones

These attributes were used earlier in this chapter in the correcting over- and under-exposure instruction. Here these settings are used in a more general way to balance a photograph that has light and dark areas.

In this photograph the reflection of the trees in the river is pleasing to look at. The contrast and colours are nice, and yet can be enhanced to be more dramatic.

1 Click the Enhance… Adjust Lighting… Shadows/Highlights menu item to display the Shadows/Highlights dialogue box. The goal is to adjust shadows and highlights to bring out even more contrast and beauty of the trees' reflection.

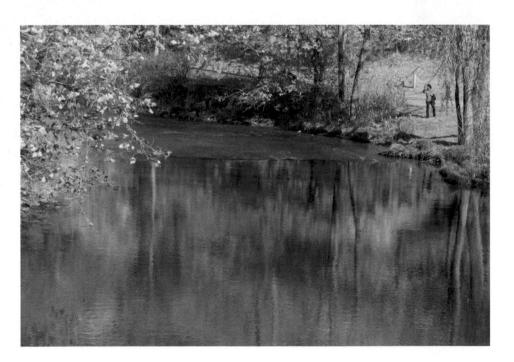

2 The Lighten Shadows setting is decreased to bring more clarity to the reflection in the water.

3 The Darken Highlights and Midtone Contrast settings are increased to accentuate the contrast of the trees.

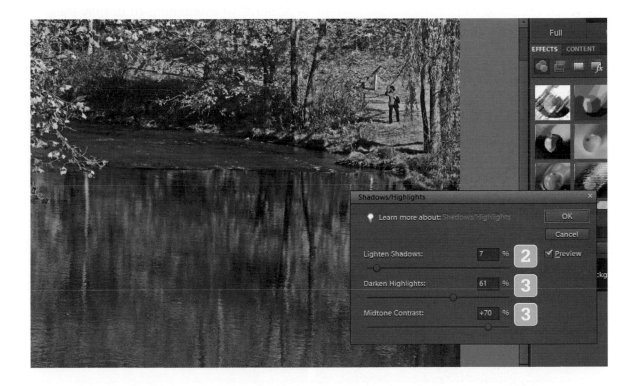

WHAT DOES THIS MEAN?

Contrast: contrast is the difference between light and dark areas in a photograph. The wider the range of light to dark, the higher the contrast.

 HOT TIP: To avoid a disparity of light and dark areas, stand further away when shooting a photograph. The photo may come out darker overall, but then it is easier to edit by adjusting the overall brightness.

Removing colour cast

Here is a photo which has an over-abundance of a tan-yellow look to what in reality is lightly shaded porcelain. These steps help correct this off-colour:

1 Click the Enhance… Adjust Color… Remove Color Cast menu item to display the Remove Color Cast dialogue box.

2 This dialogue works by using the 'eyedropper' tool to sample a colour in the photograph. Click on the eyedropper icon in the dialogue, and then click on a part of the image that needs help. A few clicks on the image will cycle through variations, as each click with the eyedropper alters the image based on the colour where you clicked.

Comparing the before and after images, the colour of the sink rim is now a bit less discoloured.

WHAT DOES THIS MEAN?

Colour cast: the unintended appearance in a photograph that non-natural lighting can create. Fluorescent lights tend to cast a green shadow in a photograph, and other lighting can also play havoc.

Adjusting for skin tone

The approach is to use a person's skin tone as a guide to adjust the overall colour balance of the image.

1 Click the Enhance… Adjust Color… Adjust Color for Skin Tone menu item to open the Adjust Color for Skin Tone dialogue box.

2 In the figure the eyedropper is poised over the cheek of the man on the right side of the image. His skin will be sampled when the eyedropper is clicked.

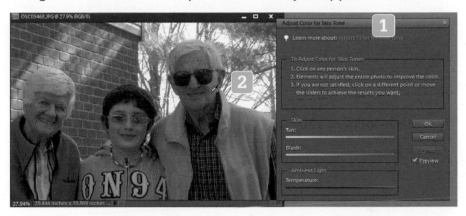

3 Photoshop Elements alters the photograph to best match the sampled skin tone. The slider switch controls can be used to further alter the tonal balance of the image.

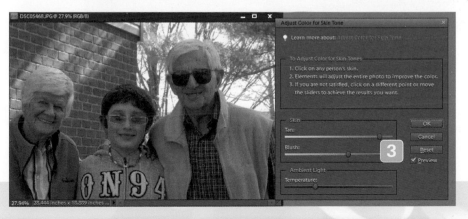

> **? DID YOU KNOW?**
>
> As with all image alterations more than one type of enhancement can be applied. The 'after' photograph is better but perhaps not good enough. An additional step can be taken: the simple Auto Color Correction can be applied to make the image bright and the colours better.

Changing colours

Photoshop Elements provides a powerful set of actions that lets you change colours. You can specify which colour to replace, which colour to replace it with and – of great use – decide a range of colour to apply the change to.

1 With a photograph in the active image area, click the Enhance... Adjust Color... Replace Color menu item to display the Replace Color dialogue box.

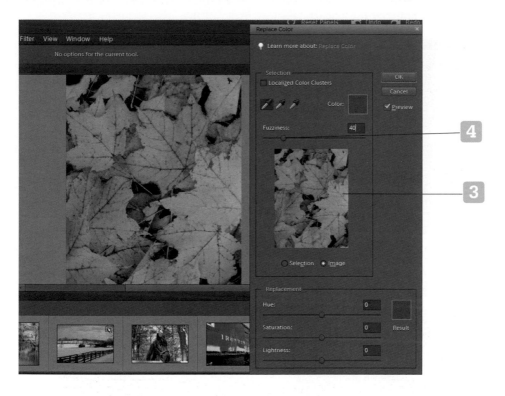

2 Using the eyedropper, click on a place on the image where you want to replace the colour.

HOT TIP: Replacing colour can be a very creative effect, especially with a good amount of applied fuzziness.

3 In the Replace Color dialogue, click in the middle section to show the Selection. The image changes to a black and white representation of the colour you clicked with the eyedropper.

4 Using the Fuzziness slider, add or subtract how much of a tonal range to include around the selected colour. This slider is what helps take away the need to click in a precise spot with the eyedropper. Increasing the Fuzziness allows more of a colour range to be included in the selection.

5 Using the sliders in the Replacement section of the dialogue, determine the desired colour to have the selection change to.

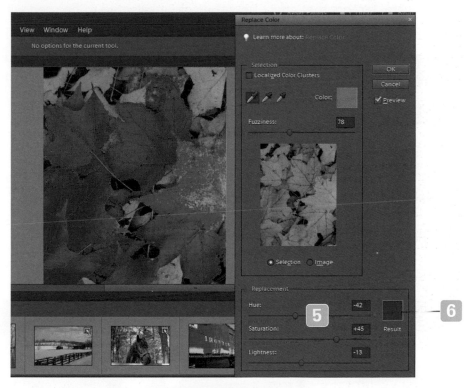

6 Click OK to close the dialogue. The selected area of the photograph displays the new colour.

HOT TIP: You can also click on the Result box and use a colour picker to target the new colour.

Changing colour in large portions of an image

The Paint Bucket tool is helpful to place a colour in a large area of an image.

1 Select the Paint Bucket tool in the Toolbox.

2 Select a foreground colour by clicking on the foreground indicator box and using the colour picker dialogue.

There are several factors that affect how the colour selected to be used with the Paint Bucket will affect the image.

In this image, a yellow colour is selected, and the Paint Bucket is used to turn the jacket from red to orange. In the tool options area a number of options are selected:

3 The type of colour change is Soft Light. There are many other choices.

4 The opacity is at 100%.

5 The tolerance is at 40. The tolerance controls how wide a range of image colours will absorb the new colour. The tolerance can be set from 0 (no effect) to 255 (the entire image is painted). With a reasonable tolerance setting, the Paint Bucket effect will stop at boundaries where the colour changes.

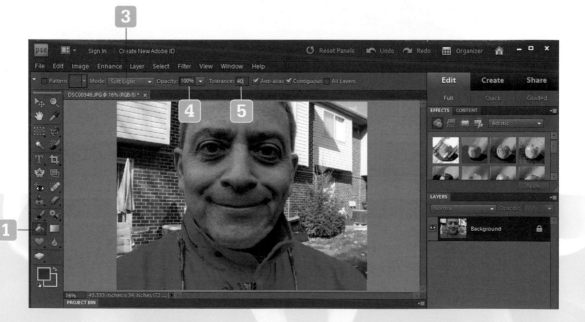

Previewing changes with Color Variations

Here is a dialogue box that displays many options at once. This lets you experiment with a number of different changes with the ease of a few mouse clicks here and there.

1 Click the Enhance... Adjust Color... Color Variations menu item to display the Color Variations dialogue box.

2 Select Midtones, Shadows, Highlights or Saturation on the left side of the dialogue.

3 Adjust the Intensity using the slider switch. This creates various thumbnail options in the bottom part of the dialogue.

4 Click on one of the thumbnails and the 'After' image in the upper right of the dialogue displays the selected change.

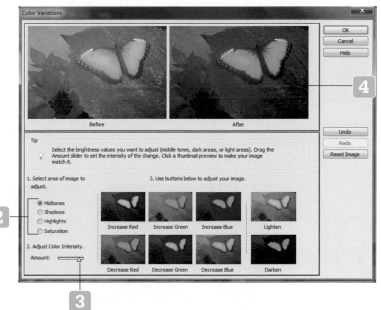

HOT TIP: The Color Variations dialogue has Undo, Redo and Reset buttons. Each time you select a variation, it's applied to the previous variation. This becomes a history of variations and you can move forward and back through them with Undo and Redo.

? DID YOU KNOW?

The effects created by settings such as 'Increase Red' or 'Decrease Green' can also be made by using photo filters – in the Filter... Adjustments... Photo Filter menu.

Eliminating colour

When colour is removed, a black and white, or greyscale, image is the result. Often used as an artful technique, black and white images make clear the contrast of subjects in the image. There are three ways to remove colour:

1. In various dialogue boxes that are used to affect colour, Saturation has been one of the components that can be altered. Bringing Saturation down to the minimal amount removes colour.

2. The Enhance… Adjust Color… Remove Color menu item instantly removes colour, leaving behind a greyscale image. The keyboard shortcut, Shift+Ctrl+U, performs the same action.

3. The third method gives you control over colour removal. Use the Enhance… Convert to Black and White menu item to display the Convert to Black and White dialogue box. In the dialogue a style is selected in the lower left, and then adjustments can be made on the red, blue and green channels, as well as to the overall contrast.

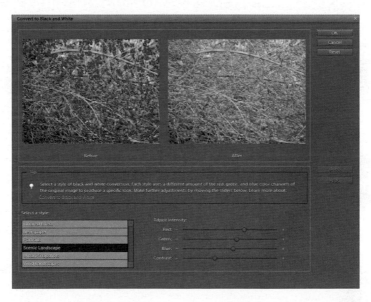

 HOT TIP: The keyboard shortcut Shift+Ctrl+U also instantly removes colour to leave a greyscale image.

 HOT TIP: Grayscale is not the same as Black and White. With Grayscale there are gradations of shades between black and white. Simple Black and White images have just those two colours.

5 Creating and using selections

Introduction

Selections are designated editable areas of an image. When a selection is put into an image, changes can be made on just the selected area.

There are many types of manipulation that can be done with selections. This chapter is about how to create selections. Making use of selected areas is explored throughout the rest of the book.

Selecting an area with the Rectangular Selection tool

The basic selection is a rectangular area.

1 Right-click on the selection tool in the Toolbox. The two types of selection tools are there for the choosing. Click on the Rectangular Marquee Tool.

2 The mouse pointer changes to a cross. Click on the image in a desired corner of where the selection will go. Hold down the mouse button and draw the rectangle over the area of the photograph.

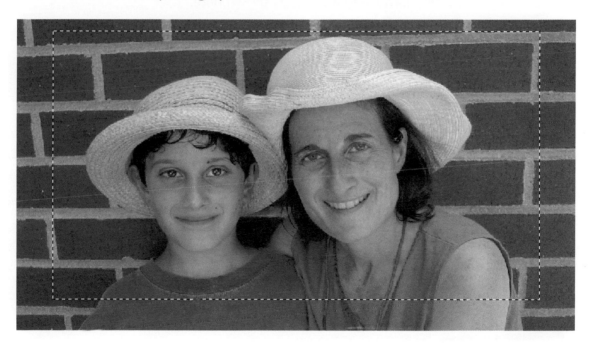

? DID YOU KNOW?

Although the terminology is about selecting and selections, the tools are named as marquees. When a selection is drawn onto a photograph it looks like a marquee. Therefore selection and marquee are interchangeable terms.

► SEE ALSO: If the Mode dropdown is disabled, the background needs to be changed to a layer. This is explained in Chapter 7.

Selecting an area with the Elliptical Selection tool

Using an elliptical tool lets you draw selections that are ovals or circles.

1 Right-click on the selection tool in the Toolbox. The two types of selection tools are there for the choosing. Click on the Elliptical Marquee tool.

As with the Rectangular Marquee tool, the Elliptical Marquee tool has three modes: Normal, Fixed Aspect Ratio and Fixed Size. Normal lets you draw an oval shape. Fixed Aspect Ratio forces the marquee to a circle, as shown here.

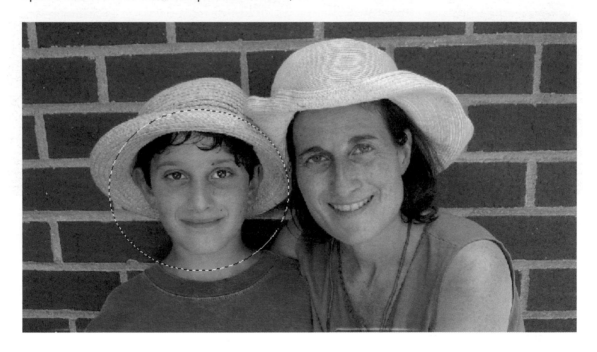

Adding to a selection

While a marquee is displayed on an image, you can apply another marquee and have the two join together.

1 Draw the first selection.

2 While holding down the Shift key, draw another selection. Make sure it touches the boundary of the first selection, or even have it start from within the boundary of the first selection.

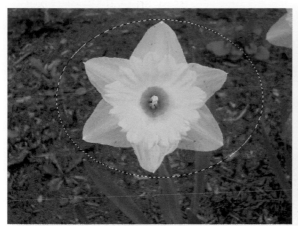 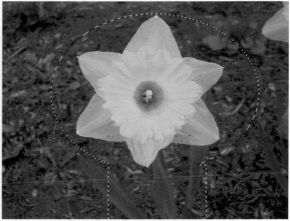

 DID YOU KNOW?
You can do this repeatedly, and can mix and match the rectangular and elliptical marquee shapes.

Setting the Feather

The Feather is the size, in pixels, of the edge of the selection marquee. At a low setting, such as 0 or 1 pixels, the selection will have a hard edge. Increasing the Feather produces a larger edge. The edge therefore has enough pixels to create a smooth transition around the marquee boundary. The effect of this is evident when the selection is put to use.

1 Select the Elliptical Marquee tool. In the tool options area set the Feather to 0px (pixels).

2 Draw a selection in the image.

3 Click the Edit… Copy menu item to place the selection on the clipboard.

4 Create a new file. Use the File… New… Blank File to open the New dialogue.

5 The defaults presented in the New dialogue are fine. Just click the OK button to create a blank image.

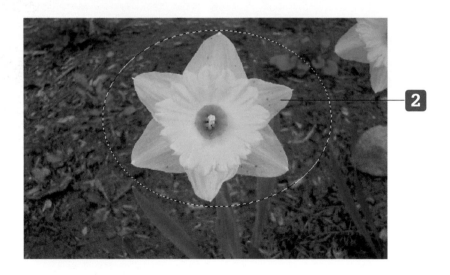

DID YOU KNOW?

You can change the size of the Feather after drawing the selection by using the Select… Feather menu.

6 Click the Edit… Paste menu item. The selection is pasted into the new blank image.

The edge of the pasted selection is abrupt, since the Feather was set for 0 pixels. Next, repeat the process, but use a Feather of 25 pixels.

7 Bring the original image into the active image area by double-clicking it in the Bin.

8 Click Undo to remove the marquee.

9 In the tool options, set the Feather to 25px.

10 Repeat drawing a selection, copying it, creating a new blank image and pasting the selection. Now the pasted selection is softer around the edges.

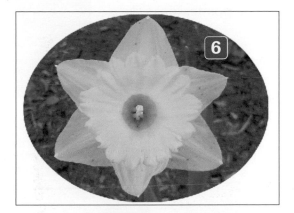

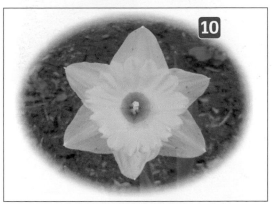

Creating freeform selections

The rectangular and elliptical selections are easy to draw onto an image, but often the desired focus areas of an image are not of such perfect proportions. A set of tools lets you select in a number of ways that will capture the portion of the image you need. The first of these is the Lasso tool.

1 Right-click on the Lasso tool and select Lasso Tool.

2 Freeform draw around an area of the image. While doing so the mouse pointer looks like a lasso.

3 Complete drawing the marquee by joining the freeform line with the beginning. Release the mouse button. The selection is now complete and will be a self-contained area.

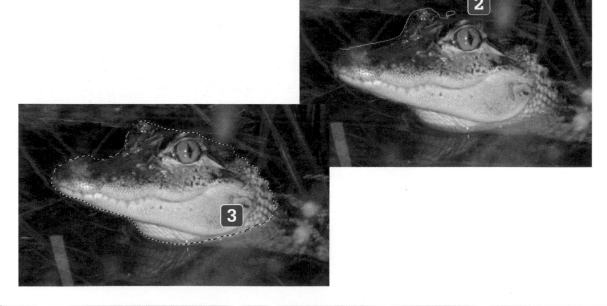

Using the Polygonal Lasso tool to create shaped selections

The Polygonal Lasso tool creates a line-to-line selection. The process is two-step. You draw a line, then click the mouse to end that line and start to draw the next line, directly from where the last one ended. In this manner the selection is continuous but the shape of the selection is the result of the individual lines and the angle of each one. Each line is a straight line but at each stop and start point the new line goes in the direction you draw.

1 Right-click on the Lasso tool and select Polygonal Lasso Tool.

2 Start drawing around the subject. Each time you need to draw in a different direction, click the mouse and then draw some more.

3 When the selection is drawn back to where it started, click the mouse to end the process. The image retains the completed selection.

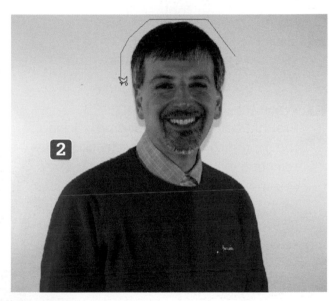

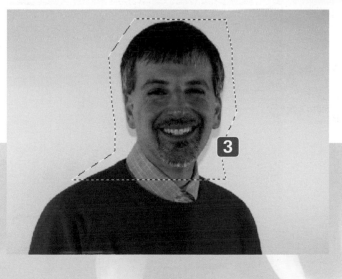

Creating irregular shaped selections with the Magnetic Lasso tool

The Magnetic Lasso tool works by snapping to a boundary that you define with a series of mouse clicks.

1 Right-click on the Lasso tool and select Magnetic Lasso Tool.

2 Place markers around the area to be selected by clicking around it with the mouse.

3 When the sequence of markers is brought back to the beginning, clicking the mouse completes the selection. The selection will snap to the boundary. The selection can be so perfectly on the area set by the markers that it is hard to see. In the second screen shot the flower is selected, although it might be hard to tell since the selection is perfectly shaped to the flower.

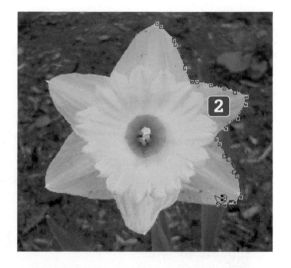

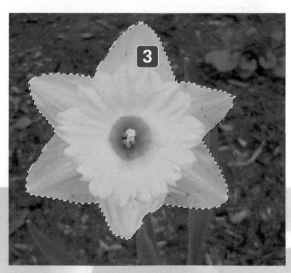

Fast selecting with the Magic Wand

In a rush? Use the Magic Wand to make the selection.

1 Click on the Magic Wand tool in the Toolbox.

2 Draw a quick line over the area to be selected. No need to try to draw around the boundaries: the Magic Wand will figure it out.

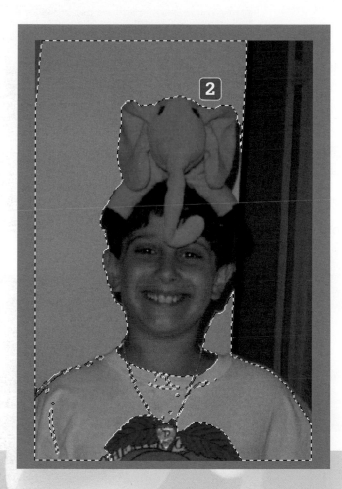

? **DID YOU KNOW?**

The tolerance setting, in the tool options area, controls how sensitive the Magic Wand is to boundaries found in the image. The higher the tolerance, the less detailed the selection will be. At a high enough tolerance the entire image will be selected (the marquee goes around the edge of the image).

Painting a selection

All the selection tools thus far have been focused on defining the selection around boundaries. Sometimes this is not necessary. Perhaps all you need is a sample from an image area. The Selection Brush Tool is the tool of choice for this chore. The Selection Brush Tool creates a selection that has nothing to do with boundaries. It simply creates the selection where you paint it on the image.

1 Choose Selection Brush Tool from the Toolbox.

2 Using the mouse, paint in a desired area of the photograph. In this example, a selection has been made of the bird's beak. The colour of the beak was the desired part of the image, not the beak itself.

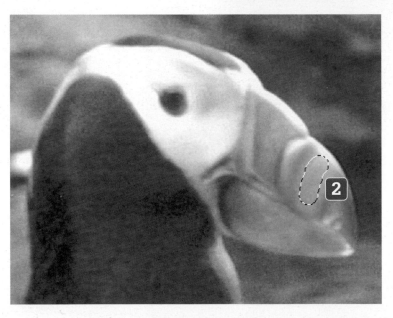

 HOT TIP: In the tool options area, the size of the brush is chosen. The selection in this example is set at 75 pixels.

Saving a selection

Creating a selection can be tedious and time-consuming. If the selection is one that can be used again – whether in the same photograph or a different one – then saving it is a great idea.

1 Create the selection in the image.

2 Click the Select... Save Selection menu item to display the Save Selection dialogue box. In the dialogue enter a name for the selection and click the OK button.

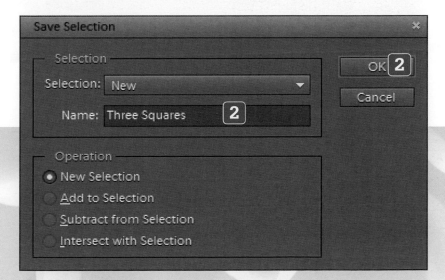

Inverting selections

When an area is selected in an image, any changes are applied to the selection. What if you need to apply changes to the area that is not selected?

Easy! In the Select menu is an item to invert the selection. The selection in the image will swap with the rest of the image.

1 Create your selection.

2 Click on the Select… Inverse menu item.

3 The appearance may seem as if nothing has been inverted but the image now has a marquee around its edge.

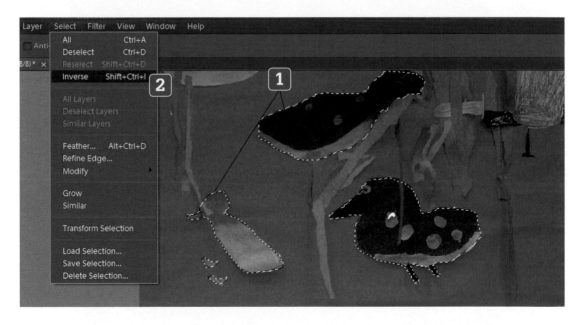

SEE ALSO: After the painstaking work of making multiple selections, save them! See page 87.

4 The ducks still have marquees but now they serve to isolate the ducks from the selection. This becomes evident when a change is applied. Here, colour has been removed from the image, but the ducks are unaffected.

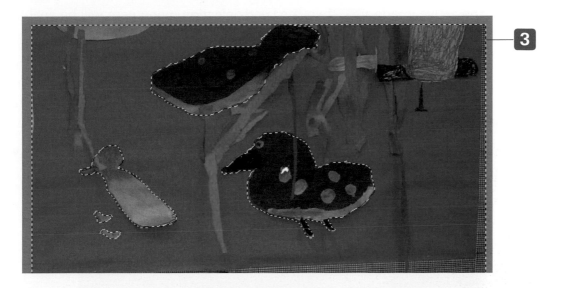

3

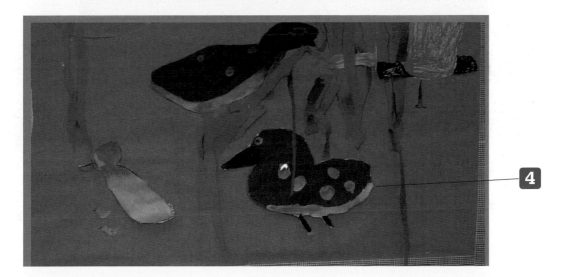

4

Loading a selection

When you need to reuse a selection, if there is a saved selection that's associated with the image in the active image area, then the Load Selection menu item will be enabled.

1 Click on Select... Load Selection to display the Load Selection dialogue.

2 If there is just one selection associated with the image, simply click the OK button. If there is more than one selection associated with the image, first choose the desired selection from the dropdown list.

3 Click the OK button. The selection will snap into the place in the image where it was saved from.

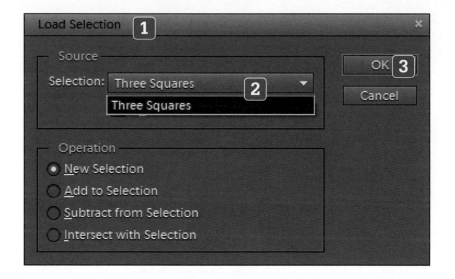

HOT TIP: You can create a selection in an image and then load a saved selection. The two will interact based on the option made in the Operation box.

6 Cropping, resizing, rotating, flipping and zooming

Introduction

Cropping a photograph is the action of removing a portion and just leaving the desired part of the image intact. Essentially cropping is like taking a pair of scissors and cutting a photograph down to a smaller size.

The other tasks in this chapter – resizing, rotating and flipping – are just as they sound. Resizing is usually used to make an image smaller. Making an image larger will take away its clarity, although a slight enlargement will not do any harm. Rotating is necessary for when you turned the camera sideways to take a shot and hence the photograph appears to be lying on its side.

Flipping is not the same as rotating. Rotation occurs by turning the image. Flipping is like viewing the image in a mirror, or as if you have turned it over and now see it through its back. Setting the zoom is simply increasing or decreasing magnification – used often to get in close for touch-up work, such as at the pixel level.

Plain old cropping

Sometimes a golden moment presents itself and you run for the camera and click away. Come what may, with digital cameras you can shoot to your heart's content, or at least until the batteries run out. And while you catch those beautiful shots, you can also get some annoying or distracting items in the photograph.

This is what cropping is for. Cut out the clutter and keep the best. Here is a photograph of a rainbow, and it was one of those moments when you have minutes, perhaps only seconds, to catch the beauty – along with the undesirable spotlights at the top left.

Those spotlights must be removed.

1. Click on the Crop tool in the Toolbox.

2. Drag the mouse in the image to create a line between what to keep and what to discard. The mouse pointer looks like the Crop tool while doing this.

3. When the mouse button is released a preview of what the image will look like appears. Just below it are Commit and Cancel icons.

4. Clicking the Commit icon (the tick mark) displays the updated image.

Cropping to a preset size

When the Crop tool is active, an Aspect Ratio dropdown is enabled in the tool options area.

The options are:

1 No Restriction: The cropping tool draws rectangular shapes freely in the image.

2 Use Photo Ratio: With this choice, the width and height options are used. The width and height settings do not strictly force the cropping boundary box to stay at those exact measurements. Instead, a width to height ratio is established. Any drawing with the cropping tool will adhere to the ratio.

3 The rest: All the other options are preset sizes. When one of these is selected, the width and height ratio is fixed. You do not have to adhere to the actual size (for example, 4 × 6 in), however, any drawing with the Crop tool will stay true to the ratio, as in this example of keeping to a 4 × 6 aspect.

Clicking the tick mark commits the crop (although there is always the Undo to fall back on).

 HOT TIP: Using a preset crop size ensures that when printed, the physical photograph will include the full image.

Moving, rotating and resizing the cropping box

When an area is in the stage of being cropped, the box can be moved, rotated or resized.

1. In the middle of the crop box is a handle. Clicking on it and holding down the mouse button lets you move the box to another part of the image.

2. Outside of the box is a handle in the shape of two opposed arrows. Clicking on this and holding down the mouse button lets you rotate the box.

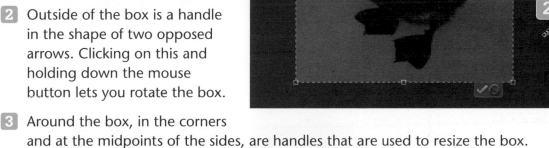

3. Around the box, in the corners and at the midpoints of the sides, are handles that are used to resize the box.

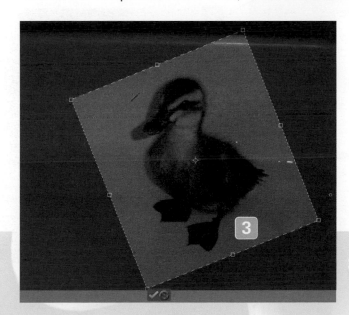

? DID YOU KNOW?

Rotating the cropping box only changes the dimensions of the cropping action. The image within the cropping box is not rotated.

Cropping to a selection

1 An alternative way to crop is to first put a selection into the image, using one of the selection tools. Then to complete the operation click the Image... Crop menu item.

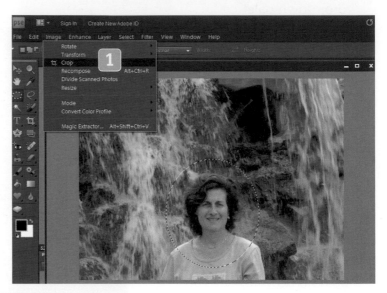

2 When the selection is not rectangular, the cropping operation will still crop to a rectangular shape, padded by 50 pixels where the non-rectangular selection was situated.

2

? DID YOU KNOW?

Cropping an image with multiple selections results in a cropped image that is as large as the range of selections.

Cookie Cutter cropping

1 In the Toolbox is a tool called the Cookie Cutter. When this tool is selected, a dropdown palette of shapes is enabled in the tool options area.

2 This tool skips the preview step and goes right to display the cut shape as a new image. You still can choose to commit or cancel the operation.

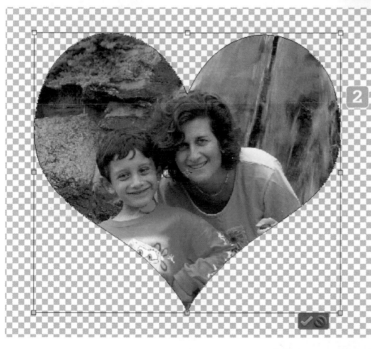

> **HOT TIP:** In the Shapes palette, click on the small double white arrow and many shape categories appear in a list – select one and the palette updates to the shapes of the selected category.

Resizing an image with the Image Size dialogue

For precise image resizing the Image Size dialogue provides full control.

1 Click the Image... Resize... Image Size menu item. The dialogue is displayed.

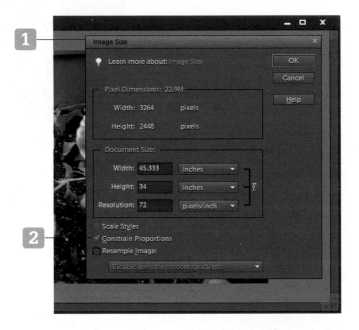

2 Initially the Document Size can be changed. Putting a new width or height and clicking the OK button will resize the image. Near the bottom left of the dialogue the Constrain Proportions option is ticked (the default). This forces the width and height to maintain a constant ratio – probably what you want, unless you purposely wish to distort the image.

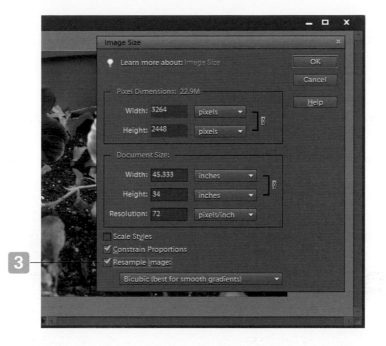

3 Ticking the Resample Image option in the lower left of the dialogue enables the Pixel Dimensions. Now the image can be resized by changing Document Size or Pixel Dimensions.

4 An easy way to resize an image is to do so by a percentage. In the dropdowns, percent is one of the choices. Here, the image starts at 100% width and height. So for a quick resize to half the size, simply put the percentage at 50%.

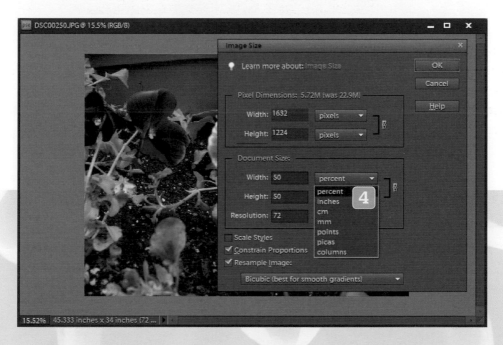

Resizing an image using the Scale feature

The other resizing method is to resize visually using handles around the image.

1 Click the Image… Resize… Scale menu item.

2 You may be presented with a suggestion to apply this type of change to a layer. If so, click the OK button.

3 The image now has handles around the edges, as well as the Commit and Cancel icons. Click on a handle, hold down the mouse button and drag to resize the image. When the image appears to be at the desired size, release the mouse button. Then commit or cancel the change.

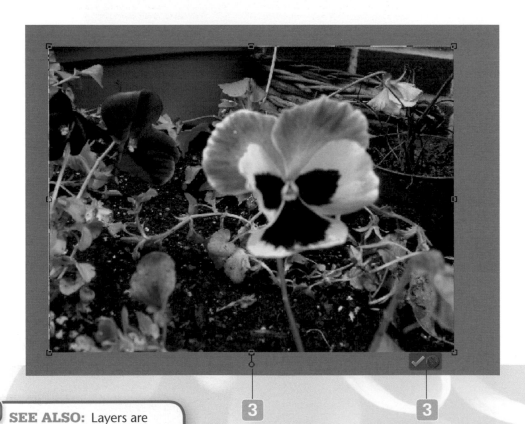

3 **3**

▶ **SEE ALSO:** Layers are explained in Chapter 7.

Rotating to a preset angle

Rotating an image may be necessary if the camera was held sideways to shoot the picture. For other images, rotating offers a different view, perhaps for an artistic effect.

With a photograph open in the active image area:

1. Click the Image… Rotate menu item. Several choices are presented.

2. Select a rotation method. Here, the image is rotated 180 degrees.

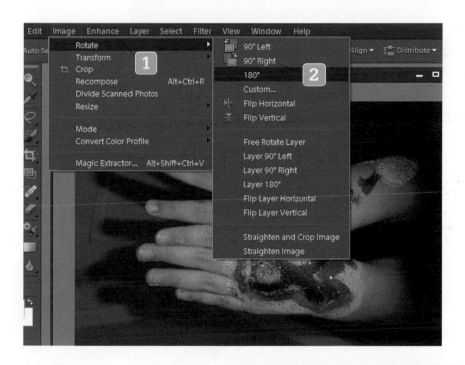

Custom rotating

1 If you select Custom, the Rotate Canvas dialogue box is displayed. In this dialogue you enter an angle (in degrees from 0 to 360) and select the direction.

2 Here, the photograph has been rotated 45 degrees to the right.

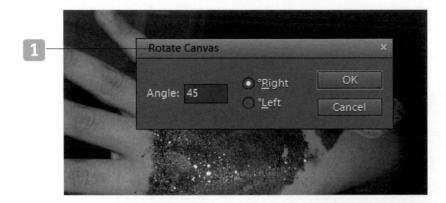

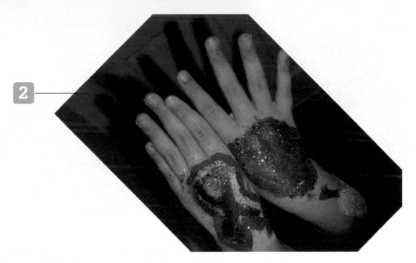

HOT TIP: Using a small custom rotating angle, such as 5 or less, is useful for straightening an image. You can even use a setting less than 1, such as 0.1.

Flipping the image

Flipping is similar to viewing an image in a mirror. Whereas rotating is analogous to movement around a clock, flipping is like turning an image over and viewing it from the other side.

1 The flipping options are horizontal and vertical, and they are found in the Image... Rotate menu choices.

2 Here is how the hands photograph appears when flipped vertically.

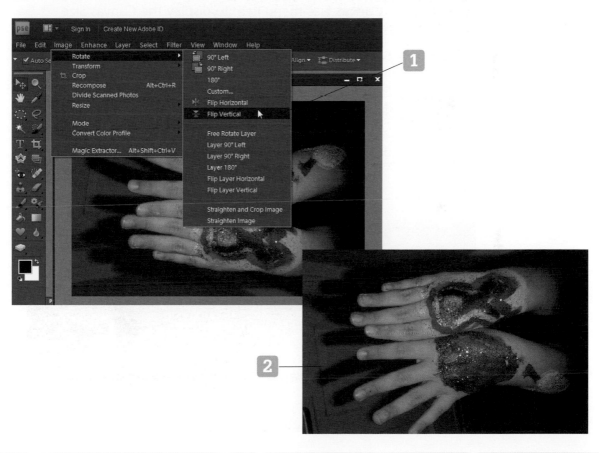

Resizing the canvas

An image sits on a canvas. The canvas is not always seen, depending on how much of the photograph is present in the active image area. If the photograph is larger than the active image area then the canvas is not seen. When zooming out (making the image smaller) the canvas will appear around the image. Although editing is done primarily on the photograph, there is the facility to make changes to the canvas.

1 If necessary, change the zoom out so the canvas is visible around the image.

2 Click the Image... Resize... Canvas Size menu item to display the Canvas Size dialogue box.

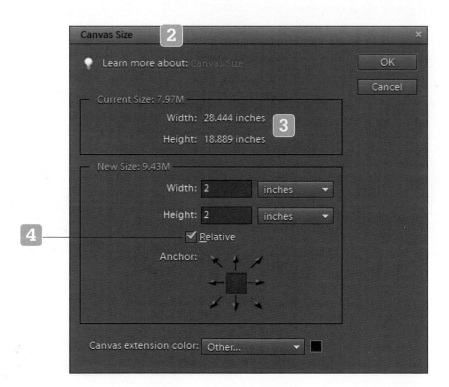

3 In this dialogue there is an area that reports the current canvas size and an area to set the new size. The new size can be set with fixed values, or relative to the current values.

4 To use the relative method, tick the Relative tickbox. New width and height amounts are entered, and dropdowns provide a choice of measurement type (percent, inches, pixels, etc.).

5 At the bottom of the dialogue is a dropdown to select a colour for the canvas. In this operation any colour selected here will apply to the extended part of the canvas, not the entire canvas. (Conversely, when creating a new image the colour of the whole canvas is selected.) Here, a deep red colour has been selected, and the colour extends out 2 inches.

By the way, the view of the image is not at 100%, it is zoomed out. The canvas extension of 2 inches is created as 1 inch on each side. It looks much smaller but a glance at the ruler bears out the truth. The image as viewed here is 20% of its real size.

Zooming

Just as the zoom lens on your camera lets you get closer to or further away from the subject, when editing the same function is necessary. Touch-up work often requires focusing on a portion of a photograph, and getting very close up to it as well. Some editing chores have to be done on a pixel by pixel basis, and that means zooming way in – much more so than what your camera can do.

Zooming back out of course is necessary to view the whole picture. So a good amount of back and forth could be on the plate for certain editing needs. Photoshop Elements provides ease when zooming.

1 Selecting the Zoom tool in the Toolbox displays the Zoom tool options above the image. To the left are zoom in and zoom out buttons (the + and – buttons). Click on one and then move the mouse over the image. The mouse pointer changes to a magnifying glass. Click on the image to apply the zoom.

2 Zoom can be selected as a percentage. 100% is the true size of the image. Increasing the number zooms in and decreasing the number zooms out. When you click on the percentage box a slider control opens beneath it and can be used to slide to a percentage.

? DID YOU KNOW?

Since 100% is the true image size, and most images are larger than can fully be seen in their entirety, images are often viewed at a smaller percentage of zoom so the whole image can be seen.

3 Clicking on the 1:1 button instantly reverts the image to 100% – the true image size.

4 The percentage can be set to many thousands above the true size. Here is an example of using the zoom at 1200% – to work at the pixel level.

5 The Navigator provides another way to zoom in and out. The Navigator is a small window that can stay open and be moved out of the way of the image. In the Navigator is a slider to control the zoom.

6 Click the Window... Navigator menu item. The Navigator is displayed.

 HOT TIP: The Navigator has a red box that sits on top of the image preview. The box shows which part of the image is displayed in the active image area. You can drag the box around and the image will follow along to display the area you moved the box to.

7 Layers

Introduction

As their name would indicate, layers are items that are layered on top of each other. The basic point of this is so that each piece of an image is essentially isolated from the rest. This provides a way of changing one piece of the image without affecting the rest.

But that's not all. Layers can be used to show or hide parts of an image. For example, you can take a single image, say a tree, and duplicate layers. There could be six layers of the tree, and on each something is different about the tree – colour, texture, you name it. Then you can toggle the visibility of the tree layers one by one and keep the one you like best. The rest can be deleted.

There are two types of layers: image and adjustment. An image layer 'displays' – the image, part of an image, type, a shape – generally the things you see. Adjustment layers are used to alter the image layers. For example, an adjustment layer that controls brightness will control the brightness of the image layers below it.

Using the Layers palette

The Layers palette is situated in the palette bin to the right of the active image area.

In the Layers palette, at the very least, is the background. When a typical image file is opened (jpeg, tif, etc.), the image is the background. Additional layers are added to create corrections and enhancements in the image. There are various layer types:

1 The background.

2 A text (or type) layer.

3 An adjustment layer.

4 An image layer.

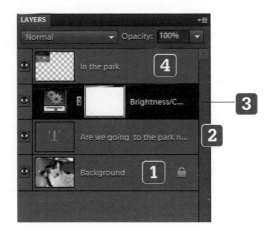

 HOT TIP: Using layers brings a wealth of editing options to Photoshop Elements. It is possible to put every unique element on its own layer and make adjustments that affect just one element at a time.

Changing the background to a layer

The effects and changes that can be applied to the background are limited. As you become familiar with what layers offer, you may want to apply these to the background. The trick then is to change the background to a layer.

1 Right-click on the background in the Layers palette.

2 In the context menu select Layer From Background.

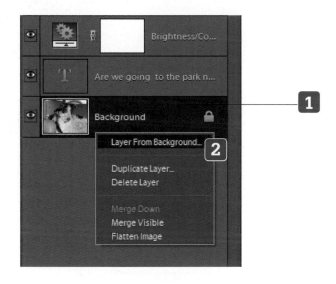

 HOT TIP: Using Layer From Background changes the background to a layer. Using Duplicate Layer keeps the background and makes a new layer that is a copy of the background.

Adding an image (shape) layer

A shape (or image) layer is really just the basic layer, and is usually referred to as a layer – plain and simple. When this type of layer is added, you can use it to add shapes to the overall image, or a part of or the whole of another photograph.

1 Click on the Create a New Layer button.

A new layer is now shown in the Layers palette, here simply named Layer 1.

On this type of layer visual elements are added: shapes, other images, and so on. Here, we will add a shape, a heart.

2 With the layer selected in the Layers palette, click on the Custom Shape tool in the Toolbox.

3 Draw the shape where desired.

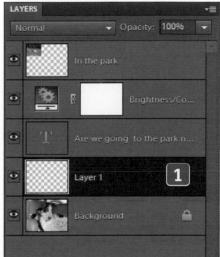

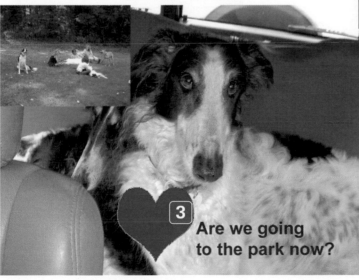

HOT TIP: Before drawing a shape don't forget to select a colour, by clicking Window… Color Swatches, or just double-clicking the forecolour box.

Adding an adjustment layer

Adjustment layers affect image layers. There are a number of adjustment types. The selected adjustment type alters just the layers that are below it.

1 Click the Create new fill or adjustment layer button in the Layers palette. A context menu appears and an adjustment layer type is selected. The names of the types are pretty clear about what they can adjust.

In this example, a Photo Filter adjustment type is selected. This action displays the appropriate dialogue for the Photo Filter selection.

2 The adjustment filter is now in the layer stack. If/when a change to the Photo Filter settings (or the settings for whatever type of adjustment layer it is) is required, double-click the layer thumbnail. There are two thumbnails in the adjustment layer: the layer thumbnail on the left and the layer mask thumbnail on the right.

? **DID YOU KNOW?**

Each type of adjustment layer has its own settings and applies its own type of adjustment. The adjustments affect the layers beneath the adjustment layer. The layers can change position, explained further in the chapter. This action changes which image layers are affected by which adjustment layers.

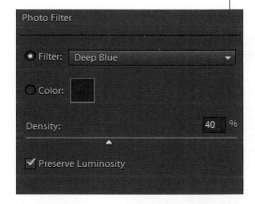

Adding a fill layer

Fill layers are a subset of the adjustment layers. There are three fill layers:

1 Solid Color: You select a colour and the colour blankets all the layers beneath the fill layer.

2 Gradient: You select a gradient and can make several selections about how the gradient appears.

3 Pattern: A pattern is selected for the fill.

This shows the image with a gradient fill. Note the placement of the layer. The gradient affects the dog, heart and type – these are layers that are beneath the gradient layer. The small image inset in the upper left is not affected by the gradient – it is situated as the top layer.

Adding a type (text) layer

A type (text) layer is added automatically when the Type tool is used. Start typing and the layer is there. In fact, you may end up with several layers of text if you broke up your text entry with other activities. Later in this chapter are instructions on how to merge layers. That might be a desired action if the text came out on several layers.

1 Select the Type tool from the Toolbox. Select any options from the tool options area. For text, you can select the font type, size and other attributes.

2 Click in the active image area and type away! A type layer is created.

3 If/when you need to edit the text or its attributes, double-click the text layer thumbnail. This highlights the text and brings the Type tool options into the tool options area. Make changes and they are saved in the layer.

Renaming a layer

Photoshop Elements provides all new layers with a name – a functional name such as Layer1, Shape2, and so on. This is adequate if a handful of layers is being used. With more sophistication – and therefore more layers – the ability to rename the layers is helpful. You can name them with distinctive monikers such as 'Playtime in the park'.

1 Simply right-click on the layer name. A context menu appears; one choice is Rename a Layer. When clicked a dialogue box opens and the name can be changed in the dialogue.

1

 HOT TIP: Another way to change the layer name is to double-click on the name as it is in the Layers palette. The name then becomes editable.

Selecting, moving and resizing content on a layer

The biggest advantage of using layers is that you can make changes to a piece or portion of an image and not disturb anything on the other layers. Adjustment layers of course do affect image layers, but that is passive. If you remove the adjustment layer, the image layer no longer has the enhancement delivered through the adjustment. Here is how one part of an image, on its own layer, can be moved and resized while the rest sits blissfully by.

1 In the Layers palette, click on an image layer.

2 In the active image area, click on the Move tool. This puts a marquee and handles around the section of image that is on that layer.

3 Move the mouse to the centre of the image. Click and hold down the mouse button. Drag the image to another location and let go of the mouse button.

4 The image is still selected. While selected, you can resize by clicking and holding down the mouse on a handle surrounding the border. Drag the handle to resize the image. When you let go of the mouse, the Commit and Cancel icons appear. Select one.

 HOT TIP: You can rotate the image by using the rotate handle at the bottom of the image.

Creating a layer from a selection

A handy technique is to turn a selection into a layer. This is useful for duplicating part of an image.

1 In an image, select a desired element. In this example, the selection tools are used to create a selection around the zebra on the left.

2 Copy the image by clicking the Edit... Copy menu item.

3 Click the Layer... New... Layer via Copy menu item. This creates a new layer that contains a copy of the selection.

 HOT TIP: If you need more copies of the selection, you can now just duplicate the layer.

Duplicating a layer

Duplicating a layer provides an easy way to add more images. Take one tree on a layer, duplicate the layer a few times, then one by one, work with a single layer and tree to move and resize the individual tree – and finally you have a forest!

This example follows the previous task of creating a layer from a selection. There is now a layer with just a zebra on it.

1 Right-click on the layer and select Duplicate Layer from the context menu.

The Duplicate Layer dialogue box is displayed and a name can be given for the new layer (here Zebra2).

2 Working with one of the identical layers, select the layer and then select the Move tool.

3 Use the Move tool to move and resize the duplicated zebra.

4 Taking it a step further, you could use the Image … Rotate … Layer 180% menu item to turn the zebra around. Now the overall image does not look as if a zebra was duplicated.

 HOT TIP: You can duplicate many layers at once. Select more than one layer then right-click on one of them and select Duplicate Layer. The number of layers you selected is the number of layers that are duplicated.

Reordering layers

With a number of layers making up the full image, options are available for how to stack the layers. Some layers will block out others; some add a new feature that appears correct in placement and therefore doesn't detract from the overall image. Adjustment layers alter only the layers underneath. So there are many variations that reordering the layer stack will create.

1 Take an image and work up a number of layers. No need to create a super work of art here. Just have at least a couple of image layers and at least a couple of adjustment layers.

2 Click on a layer and hold down the mouse button. Drag the layer up or down, whatever the case might be. Release the mouse button.

With the zebra example, the Brightness/Contrast and Photo Filter adjustment layers affect just the background. One of the zebras is treated with the adjustment. The other two zebras are on layers higher up in the stack.

? DID YOU KNOW?
The background layer must stay on the bottom of the layer stack.

Linking layers

Layers can be grouped. This provides the advantage of keeping associated layers attached so that changes will affect the linked layers together.

1 Click on a layer to select it.

2 Holding down the Ctrl key, click on one or more other layers.

3 Right-click on a selected layer and click on the Link Layers option in the context menu.

The individual layers are now treated as one. In this example, the two zebras are linked and the marquee now encases them together.

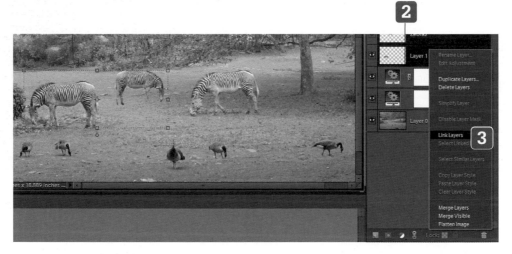

Any changes will be applied to the joined layers as if they were a single layer.

 HOT TIP: You can also link layers by selecting them and then clicking the Link icon – which is in the row of icons at the bottom of the Layers palette.

Hiding and showing layers

The ability to isolate a layer is helpful when enhancements are to be made to just the content on that one layer. Conversely there are times when hiding some layers and letting others stay visible is desirable. Here is how to do both.

1 In the Layers palette, each layer has an eye icon to the left. These toggle the visibility of the layer. Clicking on a layer's eye initially makes the layer invisible.

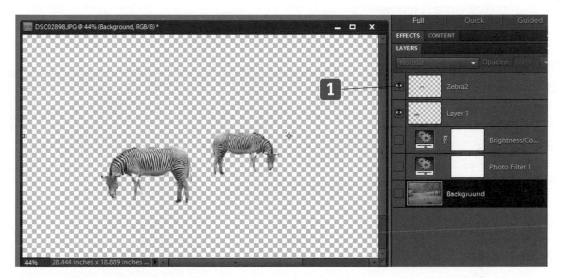

Note that when the layer is invisible the eye icon is not visible either. In this example the background layer is not visible, just the two zebras are seen.

2 To isolate one layer to be visible and all other layers invisible, either click the eye icon of each layer that should be invisible (the tedious method), or better – right-click on the eye of the layer you want to be visible by itself. A choice context menu appears. The two choices are complementary. Hide the layer, or leave the layer visible and hide every other layer.

 HOT TIP: Adjustment layers do not have a visibility property but if you click on the eye the effect of the adjustment layer is turned off (and when toggled it is turned back on).

Selecting the blend mode

Layers are stacked and therefore there is an order to how the overall image appears. Adjustment layers offer enhancements and effects that affect the overall image depending on their settings and where they are in the stack. Another method of controlling the overall image is by using blends.

Blends are settings of how the image layers will affect each other (not the adjustment layers). Normally one layer will cover up the next assuming the upper layer is set at 100% opacity. This is what happens when the blend mode is 'Normal'.

However, there are many blend modes and they can be put to use to alter the overall image. Blends are selected from a dropdown list just above the layers.

Each layer can have its own selection of blend modes. This creates numerous possibilities for creative work.

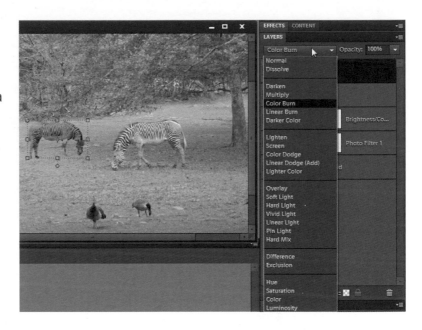

 HOT TIP: Experiment with the blend modes. There are many variations and the best way to become familiar with them is to try them out – on different layers, with different modes and with ample time to get elbow deep into the feature.

Selecting the opacity

Opacity is a measure of how solid an image element appears. At 100% opacity, the element is opaque – it has no transparency and anything underneath will not be seen. At 0% opacity, the element is completely transparent and anything underneath is seen in its entirety. Adjusting opacity provides more options of what artistic technique to apply to the overall image.

Opacity is set per layer. There is a slider just above the layers and the selected layer(s) receives the change in opacity. This example shows three boxes – blue, green and red. They are offset from each other but with some overlap. The layer stacking order, top to bottom, is blue, green and red. Blue and green are set at 50% opacity. Red is at 100%. The blue and green layers show a blending effect with each other and the red layer, producing other hues. Red is left at 100% since it is the bottom layer. Nothing is underneath the red layer that could be rendered unseen.

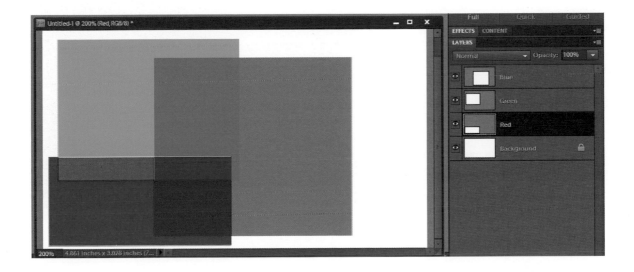

HOT TIP: Opacity can also be set for adjustment layers.

8 Working with shapes

Introduction

Besides managing and editing photographs, Photoshop Elements has a robust set of tools and methods for working with shapes. With rectangular, elliptical and a slew of custom shapes, the palette of your imagination can make image magic. There are many ways to alter, resize, line up, change colour and do more with shapes. Throw using multiple layers into the mix and you can create 3-D images.

Creating a new image

Underneath any image is the canvas. When you open an existing image file the canvas is there but not noticeable. With a new image, though, the canvas has to be created. The task of creating a new image is synonymous with creating a canvas or with creating the background. The 'blank' that shapes or images are placed upon might be called the background or the canvas. (The terms are interchangeable.) So the first step in creating any new image is to create the canvas.

1 Click the File... New... Blank File menu item to display the New dialogue box.

2 In the New dialogue, enter a name for the new work of art. Size also is selected here. There is a dropdown with standard preset sizes, such as 640 × 480 pixels to match the minimum common monitor size (this is called the Web preset). The resolution is also selected or left at the default. Selecting a preset size and resolution does not lock you in. You can change the width, height and resolution, and colour mode can be selected as well.

3 Of a bit more pertinence is the background colour of the canvas. It often is left at the White default, but there are other options. The canvas can be set to the current background colour, or can be left transparent.

4 When all the desired attributes are selected or entered, click the OK button.

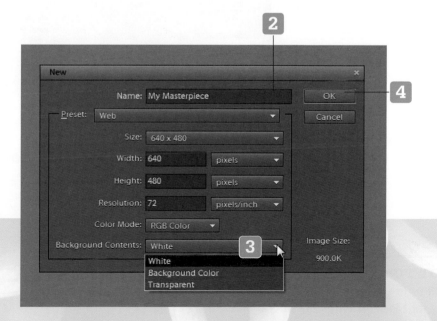

Selecting the colour for a new shape

A shape has size and colour. The colour can be selected before the shape is drawn by changing the foreground colour, or the colour can be changed after the shape is drawn on the canvas.

1 Click on the foreground colour box to open the Color Picker dialogue. The current foreground colour is displayed in the dialogue.

2 Use the hue and luminance controls to select a new colour, or enter values in the HSB, RGB, or hex # boxes. The colour box towards the upper right of the dialogue displays the new colour being selected (on top) and the current colour (on bottom).

3 Click the OK button. The selected colour is now the foreground colour, and is reflected as such in the foreground colour box.

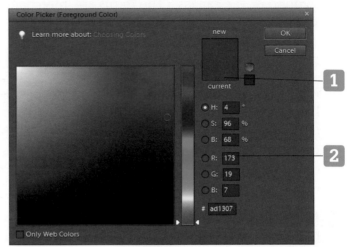

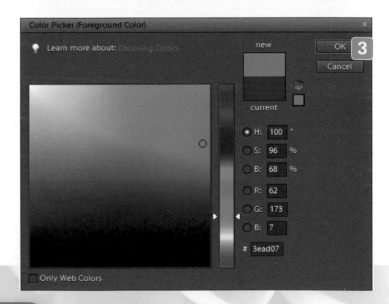

 HOT TIP: When using the RGB settings – enter a 0 in each box for black, or enter 255 in each box for white.

Adding a shape to the image

Shapes are selected with the Shape tool in the Toolbox. There are several variations of the tool.

1 Right-clicking on the tool displays the choices. In this example the Rectangle Tool is selected.

2 Click on the canvas, and while holding down the mouse button, draw the shape. When done, release the mouse button. The shape appears on the canvas, in the selected colour and shape. Also, a new image layer is created.

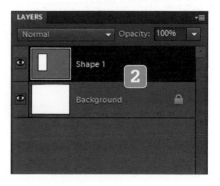

 HOT TIP: When the Custom Shape Tool is selected, a dropdown of various shapes is available in the tool options area.

Applying a style to a shape

In the tool options area is a dropdown to select the styling of the shape.

1 Click the Style button in the tool options area. A palette of styles opens. The palette displays styles that are grouped by a category, such as Bevels or Drop Shadows. In the dropdown is a set of double white arrows at the upper right. Clicking here in turn opens another dropdown of the style categories.

2 Another category can be selected.

3 The style selections update to the selected category. Then a particular style is clicked and the shape updates to the style.

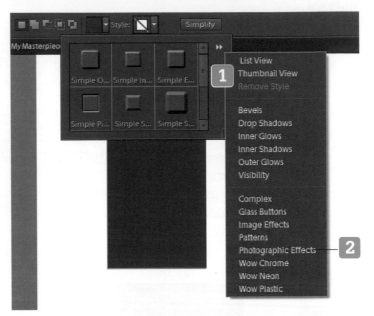

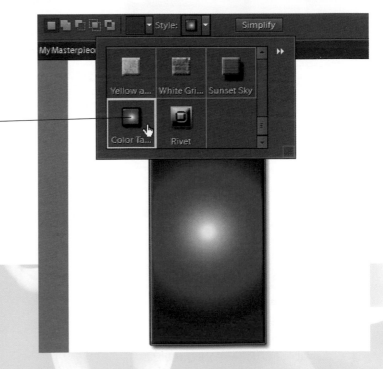

Removing a style from a shape

To remove a style, the style palette and dropdown list are used, but the particular selection of choice is Remove Style.

1 Click on the Style button in the tool options area. Click the double white arrows in the Style palette to display the style categories. Click on Remove Style.

2 All style is removed. The shape now has a flat appearance, in its original colour.

 HOT TIP: Duplicate a layer that has a shape and style, then remove the style from the shape on the new layer. Now you have two versions of the shape – one with the style and one without. You can toggle the visibility of the layers to show or hide the style.

Resizing a shape

A shape can be resized when it is selected. Once the shape is in a selected state, it has handles around the edges. These can be clicked on and used to drag the shape into new dimensions. The shape not only can be reduced or enlarged with a fixed ratio of width and height, but can also be resized such that the ratio is altered. This means that a rectangle can become a square, an oval can become a circle, and so on.

1 The shape has to be selected. Here are a couple of ways:

- Click on the Shape Selection tool in the tool options area. Then click on the shape. Handles appear around the shape. The Shape Selection tool looks like an arrow pointing to the upper left.

- Click on the Move tool. Then click on the shape. Handles appear around the shape. The Move tool is the first tool in the Toolbox – top left.

2 Click and hold down the mouse on one of the handles. Drag the mouse and the shape will change accordingly. Release the mouse button when done. The shape will now have the Commit and Cancel icons. Click the tick mark if you want to keep the change in shape.

2

 HOT TIP: When selected, there is a circular handle below the shape. Use this handle to rotate the shape.

 HOT TIP: If you hold down the Alt key the shape will resize from both sides. Try this technique to see how it works.

Adding to a shape

Even though there are several preset shapes to choose from, there are methods to alter a shape by adding to, or subtracting from, the shape.

1 Make sure the Shape tool options are displayed in the tool options area. If not, click on the Shape tool in the Toolbox.

2 In the Layers palette, select the layer that has the initial shape.

3 Click on the Add to Shape button.

4 Draw an additional shape that overlaps the first shape.

5 The shapes are combined, but still in a selected state. Click the Select… Deselect Layers menu item.

6 Once the selection is removed the result is a single custom shape.

SEE ALSO: A style can be applied to the combined shape. See page 132.

Subtracting from a shape

Subtracting from a shape removes a part of the shape – which results in a custom shape.

1 Make sure the Shape tool options are displayed in the tool options area. If not, click on the Shape tool in the Toolbox.

3

2 In the Layers palette, select the layer that has the initial shape.

3 Click on the Subtract from Shape button.

4 Draw an additional shape that overlaps the first shape.

5 The shapes are combined, but selected. Click the Select… Deselect Layers menu item. The result is the custom shape – the original shape with part of it removed.

4

5

 HOT TIP: After clicking the Subtract from Shape button, draw the new shape within the first shape – this removes material from the middle of the shape, creating an interesting effect.

Intersecting shape areas

Intersecting shapes removes all sections of the shapes that do not overlap. The remaining custom shape is the shape of the overlapped area.

1. Make sure the Shape tool options are displayed in the tool options area. If not, click on the Shape tool in the Toolbox.

2. In the Layers palette, select the layer that has the initial shape.

3. Click on the Intersect shape areas button.

4. Draw an additional shape that overlaps the first shape.

5. The shapes are combined, but selected. Click the Select... Deselect Layers menu item. The result is the custom shape – just the areas of the two shapes that overlapped.

HOT TIP: After clicking the Intersect shape areas button, draw the new shape within the first shape – this reduces the combined shape to be the same as the new shape.

Excluding overlapping shape areas

This technique retains the parts of the images that do not overlap and removes the overlapped area.

1. Make sure the Shape tool options are displayed in the tool options area. If not, click on the Shape tool in the Toolbox.

2. In the Layers palette, select the layer that has the initial shape.

3. Click on the Exclude overlapping shape areas button.

4. Draw an additional shape that overlaps the first shape.

5. The shapes are combined, but selected. Click the Select... Deselect Layers menu item. The result is the custom shape – the combination of the parts of the shapes that did not overlap.

HOT TIP: With the ability to add to a shape and exclude from a shape, you can create any shape, no matter how complex or odd it might appear.

Changing the colour of a shape

In the tool options area is a colour selector.

1 Make sure the Shape tool options are displayed in the tool options area. If not, click on the Shape tool in the Toolbox.

2 To the left of the Style button is a button with a colour on it. Either click on the button to display a colour selector dialogue, or click on the arrow next to the button to display a colour swatch.

3 Click on a new colour and the shape is set to that new colour.

? DID YOU KNOW?

Clicking Options lets you select other colour swatches, such as Photo Filter Colors and Web Spectrum.

Aligning shapes

Aligning is the action of lining up shapes. Aligning can be to the left, right, centre, top, bottom or middle.

1 Have more than one shape visible in the active image area.

2 Select the multiple shapes by selecting the associated layers, or use the Move tool to group them together.

3 When selected together a bounding box is visible around the group. In the tool options area, the Align dropdown is enabled. In the dropdown are the various alignments.

4 In this example, the Left Edges alignment is selected. The shapes are lined up on their left sides.

HOT TIP: Arranging shapes is the action of setting the layering of the shapes. This is useful when shapes overlap. Arranging lets you choose which shape is on top.

Distributing shapes

Distributing is the action of creating an equal amount of space between multiple shapes. The choice of how to distribute the shapes is the same as when aligning shapes.

1 Have at least three shapes visible in the active image area.

2 Select the multiple shapes by selecting the associated layers, or use the Move tool to group them together.

3 When selected together a bounding box is visible around the group. In the tool options area, the Distribute dropdown is enabled. In the dropdown are the various distributions.

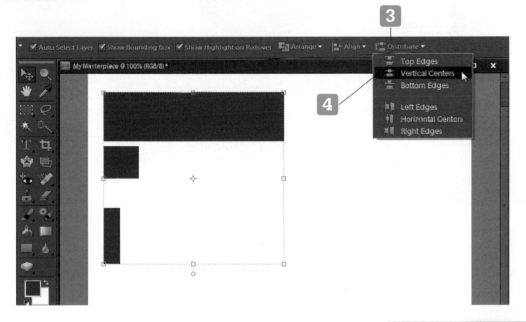

4 In this example, the Vertical Centers distribution has been applied.

? DID YOU KNOW?

Distribution requires at least three shapes. The action is to create equal spacing. With only two shapes distribution does not make logical sense.

Combining shapes

With the versatility of layers it's a breeze to combine shapes. Since each shape is on its own layer, colour, position and every other attribute can be applied to one shape without affecting others. Here is an example of placing one shape over another and then merging them into one.

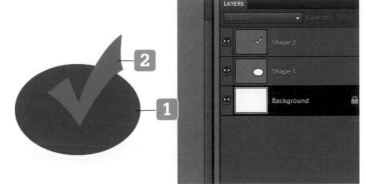

1 Place a shape on the canvas. This action creates a layer for the shape.

2 Place another shape onto the canvas. As the second shape to be added, its layer sits on top of the first shape's layer. Note that each shape is on a separate layer.

3 With both layers selected, click the Layer… Merge Layers menu item (the same option is available with a right-click on one of the selected layers).

4 The two layers are merged – the two shapes are one composite shape. Note that the two shapes are now together on one layer.

 HOT TIP: Just before merging the layers, duplicate them. Then you have both the combined shape on one layer and the individual shapes on their own layers.

Simplifying a shape

In Photoshop Elements the Simplify action converts a vector shape to a raster shape. A vector shape is based on a mathematical calculation and has the same quality at any size. A raster shape is based on pixels. Detailed editing work is often done at the pixel level.

1 Draw an image on the canvas. Click the Simplify button in the tool options area.

2 The shape is now based on pixels; this is clear when the shape is zoomed in on.

3 The shape can be altered at the pixel level. This makes for very detailed touch-up work.

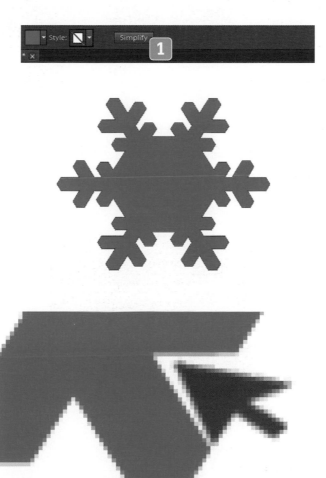

9 Drawing, patterns and gradients

Introduction

For those with an artistic flair, Photoshop Elements provides a wealth of drawing tools. The all-purpose brush is the tool of choice for most drawing needs. A brush can be tailored to be blunt, soft, large, small and a number of settings in between. The Pattern Stamp puts cool patterns right where you need them. And gradients – well, you'll just have to see these amazing visuals for yourself.

Drawing with a brush

In the Toolbox, the Brush tool has four variations: Brush, Impressionist Brush, Colour Replacement and Pencil. To start a basic drawing the prudent course of action is to use a basic brush – the plain Brush tool.

1 Right-click on the Brush tool in the Toolbox and select the Brush tool.

2 The tool options area has several settings for the brush:

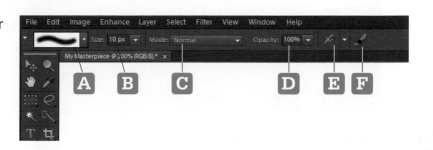

- **A** Brush type
- **B** Size
- **C** Mode
- **D** Opacity
- **E** Airbrush
- **F** Additional options

3 Without changing any settings, move the mouse into the active image area, click, hold and drag the mouse around. Release the mouse button. You have created a basic brush stroke.

SEE ALSO: Techniques presented in this chapter are used with a blank canvas. See Chapter 8 for details on creating a new image canvas.

HOT TIP: As you draw with the brush, pause, release the mouse button, then press down the mouse button and continue. This makes it easy to undo a mistake right when you make it without having to start the whole drawing over again.

Selecting a brush type

There are more brushes here than Van Gogh could possibly use, but this is the digital age, so any art program worth its salt must present a near endless variety.

1 In the tool options area, click the Brush type button. A set of brushes is available in a palette.

2 In the Brushes palette is a dropdown that lists several categories of brushes. Clicking on any of the categories loads the palette with the associated brush types.

 HOT TIP: One of the categories is Special Effect Brushes. These provide shapes, such as a flower and a butterfly, which can be entered into an image. Drawing with one of these brushes creates a stream of shapes, such as a group of butterflies flying together.

Selecting the brush size

1 Clicking on the Size box in the tool options area displays a slider control for selecting the brush size.

2 The brush size can be significant. This shows three lines, respectively sized at 50, 100 and 250 pixels.

 HOT TIP: In the tool options area, to the left, is a dropdown that displays several preset sized brushes to select from.

Altering a drawing with the Impressionist Brush

The Impressionist Brush applies a softening effect to an image.

1 Draw or open an image.

2 Right-click the Brush tool in the Toolbox and select the Impressionist Brush. A new button is displayed in the tool options area. Clicking it opens a dropdown with a variety of styles to select from.

3 Experiment with the various settings to see the effect they produce. Here, the chimney and the tree are altered. A small brush size was used to keep the affected area small.

Using an Impressionist Brush with a large brush size can alter the entire image with one stroke.

 HOT TIP: Becoming familiar with blending modes will greatly increase your versatility in creating great art. It's useful to print out the description of blend modes and keep it near your computer for quick reference.

Using the Eraser

As expected from its name, the Eraser clears wherever it is applied.

1 Right-click on the Eraser tool in the Toolbox and select Eraser Tool.

2 Drag the Eraser over the image. The image is erased where the Eraser is dragged over. The Eraser can be sized just like the brushes.

HOT TIP: If you need to erase a defined shape or colour, use the Magic Eraser Tool (one of the Eraser Tool types). With a click this will erase entire areas – with the area being defined by the tolerance setting.

Using the Pattern Stamp

This interesting tool paints a pattern in the image. The pattern can be geometrical, scenes from nature, artistic surfaces and many other textures.

1 Right-click the Stamp tool in the Toolbox and select Pattern Stamp Tool.

2 In the tool options area is a button to select a pattern. Clicking the button opens a pattern palette, and clicking the double white arrows displays a list of pattern categories.

3 Patterns are stroked across the image area, similar to the brush. This size can be changed just like the brush. Here, the image is being filled with a rock pattern.

 HOT TIP: In the tool options area is a mode selection dropdown. Using different modes with various patterns creates very interesting effects.

Using the Gradient tool

Gradients are blends of colours. The number of colours, the ratio of blending between colours, the smoothness of the blends, and the direction of the blend are all options when using gradients.

1 Click the Gradient tool in the Toolbox. The tool options area displays selections particular to manipulating gradients.

2 Click in the image area and drag the mouse. A line is drawn.

3 When the mouse button is released, the gradient appears.

 HOT TIP: Selecting a mode such as soft light or linear light creates an interesting banded effect in the image, based on the colours of the gradient.

Selecting the Gradient pattern

In the tool options area, on the left side, is a button with a dropdown arrow. Numerous gradient patterns are available in the dropdown.

1 Click the arrow next to the gradient sample. A palette with gradient samples is displayed.

2 Click the double white arrows in the palette for a choice of gradient categories.

3 Select a gradient. Then drag the mouse across the image area. When the mouse button is released the new gradient appears.

? DID YOU KNOW?

A gradient can be made from two or more colours. Many of the gradient categories have gradients made up from numerous colours. One category, Simple, has gradients made from just two colours.

Selecting the Gradient direction

1 In the tool options area are five buttons for selecting the direction of the gradient.

A Linear Gradient

B Radial Gradient

C Angle Gradient

D Reflected Gradient

E Diamond Gradient

2 Each gradient direction paints a different picture, literally. Here, for example, is an Angle Gradient.

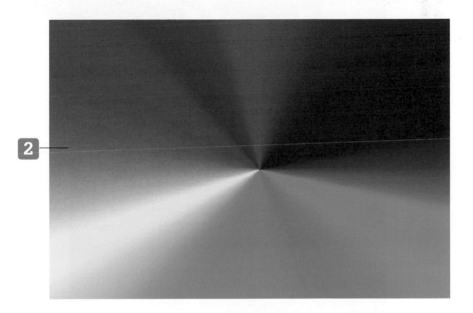

 HOT TIP: With the Radial and Diamond Gradients, the shape of the circle or diamond matches the length of the line drawn with the tool.

Using the Gradient Editor

In the tool options area is an Edit button. Clicking it displays the Gradient Editor.

The Smoothness percentage factors how smoothly one colour blends into the next.

Opacity stops and Color stops are used to alter the dynamics of the gradient. The Opacity stops are the black boxes above the colour strip. The boxes below the colour strip are the Color stops, and each displays the colour it controls.

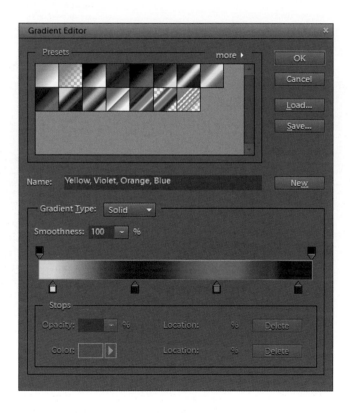

HOT TIP: Experiment with changing gradients from Solid to Noise using the Gradient Type dropdown. Noise-based gradients contain many colours.

1. Click just above the colour strip to set a new Opacity stop. This determines a position where the opacity level can be changed. The percentage of opacity is set in the Opacity box (clicking the arrow provides a slider switch).

2. Clicking on a Color stop allows you to alter the colour by using the Color box. The position of the Color stop can be changed by entering a value in the percentage box or just dragging the stop itself.

3. Clicking just below the colour strip sets a new Color stop. To remove a Color stop, click on it and drag it away from the strip. Here, the orange Color stop has been removed.

4. The smoothness is changed with a slider control. The percentage determines how hard or soft the blend is between colours.

5. Click the OK button to close the Gradient Editor.

6. Drag the mouse across the image area. Release the mouse button and the gradient will update to the customised look.

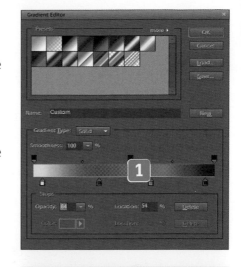

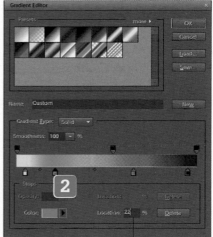

10 Working with type

Introduction

A picture says a thousand words. Can words replace pictures? They certainly can be used with pictures for enhanced impact. Photoshop Elements manages text in much the same way as images themselves. Text is editable, text goes on layers and there are text effects to use. One thing it won't do is help you compose what you wish to say.

Entering horizontal text

Left to right is the most common and familiar way for text to appear.

1 Right-click on the Type tool in the Toolbox and select Horizontal Type Tool.

2 Click in the image area and type.

3 To complete the entry, click on the Commit button on the right in the tool options area, or just click on the Type tool.

SEE ALSO: Techniques presented in this chapter are used with a blank canvas. See Chapter 8 for details on creating a new image canvas.

DID YOU KNOW?
In the tool options area is an alignment setting for setting text as left, centred, or right aligned.

Entering vertical text

Getting fancy in your graphics? Vertical text is a pleasing alternative for short snippets of type.

1 Right-click on the Type tool in the Toolbox and select Vertical Type Tool.

2 Click in the image area and type.

3 To complete the entry, click on the Commit button on the right in the tool options area, or just click on the Type tool.

Editing all the text on a layer

1 Select the layer the text is on.

2 Click the Type tool.

3 Make the desired changes using the selections available in the tool options area. There are several things you can do: change the font; change the size of the font; set bold, italic, underline, and strikeout attributes. You can change the colour of the text by clicking on the foreground colour box and selecting a new colour in the Color Picker dialogue box.

HOT TIP: You can make a change to multiple text layers at the same time by selecting them first in the Layers palette.

Applying artistic styling

1. Towards the right side of the tool options area is a Style dropdown. Clicking this opens a palette of styles.

2. Clicking the double white arrows on the right side of the palette displays a dropdown with numerous style categories.

3. Select a category – the palette updates to the styles of the category – and then click a particular style. The text is altered to appear in the selected style.

HOT TIP: Apply a style to type. Duplicate the layer and apply a different style to the type on the new layer. Lower the opacity on the top layer to 50% and the two styles will blend into a hybrid style.

Warping text

Towards the far right of the tool options is a button with a letter T sitting over an arc. Clicking this button opens the Warp Text dialogue box.

1 In the dialogue is a dropdown with numerous warp effects.

2 When a warp style is selected, the dialogue has other settings to further refine the warp effect.

3 When the desired warp effect is achieved, click the OK button to close the dialogue. The result is warped text.

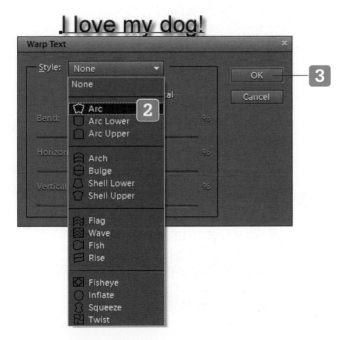

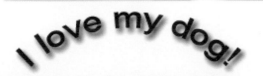

? **DID YOU KNOW?**

The shadow effect is added by applying a style selection in the tool options area.

11 Enhancing your photographs with blur and sharpen techniques

Introduction

Blurring may sound like a non-useful technique at first, but applied with thought can produce some very interesting images. In fact, blurring can bring focus to your photographs. If that sounds contradictory, consider that if part of an image is made blurry, the part left intact gets the focus – in terms of a viewer's attention. You will see this technique in the Getting sharp task.

Applying sharpness is the other side of the coin. If you have something in an image that is blurry but should not be, adjusting sharpness is just what you need.

Applying Average blur

Average blur, simply put, takes the colour values of the pixels in the selection, calculates the average colour, and then applies it to each pixel. The result is a single colour area. The resultant area does not appear blurry; it appears devoid of any variation. As such its use is limited at best to small areas. Applying an Average blur to a full image would just make one solid colour out of the image.

1 In a photograph look for a small area that needs a touch-up – perhaps a spot of glare or a blemish on a person's skin, etc. In this example, there is a small reflective spot produced by the flash reflecting off an earring. The earring is not seen, but the reflection is.

2 The Zoom tool is used to get the image blown up to the pixel level.

3 Select the Elliptical Marquee tool. Set the Feather (in the tool options area) to 3px, and then draw an oval around the glare spot.

4 Average blur is applied. It is the Filter... Blur... Average menu item. Once the blur is applied the Select... Deselect menu item removes the marquee.

While still zoomed in the appearance might look a bit odd or uneven. However, once you return to normal view the change will show the desired effect – the glare is gone.

HOT TIP: If a colour-flattened area is produced with the Average blur, it can be further worked on to blend in using the smudge tool, clone stamp or other blur methods.

Blur and Blur More

Blur and Blur More work in the same way, except that Blur More applies the effect to a greater degree. Blur and Blur More work by averaging colours along the edges of clearly defined lines and shading. This differs from Average blur which simply averages all colours.

1 Find an image or area of an image that could benefit, perhaps for an artistic effect, with being blurred. If it's an area within an image, draw a marquee around it with a selection tool.

2 Click the Filter... Blur... Blur (or Blur More) menu item. This step can be done repeatedly until a satisfactory level of blur is reached.

Using Gaussian Blur

Gaussian Blur provides more control over the blurring effect. A dialogue box provides a slider control to set how dissimilar pixels have to be for the blur to be applied. Generally the higher the setting, the more of the blur effect is produced.

1 Click the Filter... Blur... Gaussian Blur menu item to display the Gaussian Blur dialogue box.

2 Set the Radius – the width of pixels that the blur is acting upon. A larger number contains more pixels and therefore produces more blur.

3 Click OK to apply the blur and close the dialogue.

HOT TIP: This blur effect is very useful when applied to a section of a photograph. In this example, the hippopotamus's face was placed as a selection using the Magnetic Lasso tool. Then the selection was reversed using the Select... Inverse menu item. The blur therefore was applied to the whole image, except the face. The result is a blurred image with the non-blurred face.

Using Motion Blur

Motion Blur works by setting the blur effect in a selected direction (the angle of the blur).

1 Click the Filter... Blur... Motion Blur menu item to open the Motion Blur dialogue box.

2 Set the angle – the direction of the blur.

3 Select a pixel distance – the width of pixels used for the blurring method. A higher number creates more blur.

4 Click OK to complete the blur and close the dialogue box. The result is as shown.

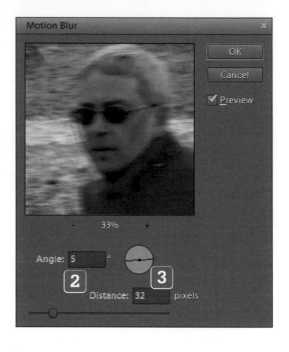

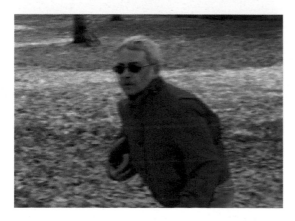

? DID YOU KNOW?

This technique is used quite a bit in action scenes – sports, for example. Applying a selection around the moving figure, you can apply the blur to the subject (the background stays sharp), or apply the blur to the background (the subject stays sharp).

Using Radial Blur

Radial Blur is a neat tool. It blurs in a circular motion. This creates many possibilities such as the appearance of tyres in motion or a globe being turned. Here, a clock is used for the effect.

1 Click the Filter... Blur... Radial Blur menu item to open the Radial Blur dialogue box.

2 In the dialogue is a blur choice of Spin or Zoom. Zoom creates the effect of the blur radiating out from the centre. Spin creates the circular blur. This example shows the effect applied to a clock.

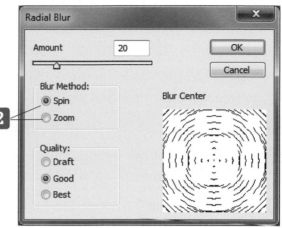

HOT TIP: Using a mix of Motion Blur and Radial Blur you can take a photograph of a parked car and make it look like it is speeding along. Motion Blur is used to simulate the blurred background and Radial Blur is applied to the tyres so they appear to be spinning.

Using Smart Blur

Smart Blur provides a variety of settings together in one dialogue:

- Radius: a measure of how many pixels are used to calculate the blur effect.

- Threshold: determines how different the pixels have to be for the blur to include them in the effect. A higher threshold results in a higher degree of blur.

- Mode: Normal works on the entire image; Edge Only and Overlay Edge work on where significant contrast occurs, typically along defined lines.

1 Click the Filter... Blur... Smart Blur menu item to open the Smart Blur dialogue box.

2 The interplay of the settings can create effects from subtle to wildly artistic. First, here is an example of applying Normal mode with a high threshold.

3 This next example is created using the Edge Only mode.

Normal mode with high threshold

Edge Only mode

HOT TIP: Using the Edge Only mode, the amount of edge detail is controllable. There could be a good amount of edges showing – and that makes it clear what the subject is. Applying the setting to display less detail could leave the 'suggestion' of an image – a very useful artistic effect.

Getting sharp

Blurring a photograph is one thing. Getting a blurry photograph to look sharp is quite a different animal. A blurred original can, at best, get clearer with some techniques, but there is no magic to making it all clear and sharp.

Photoshop Elements provides a handy enough utility to get a good crack at improving a blurry image. This is a dialogue of selections to essentially reverse a blur. This is adequate, or not; it depends on the original and how close to perfect you need it to be.

1 Click the Enhance… Adjust Sharpness menu item to display the Adjust Sharpness dialogue box.

2 In the dialogue are settings for the amount of 'unblur' to apply, and the radius – the width of pixels used to calculate how the effect is applied.

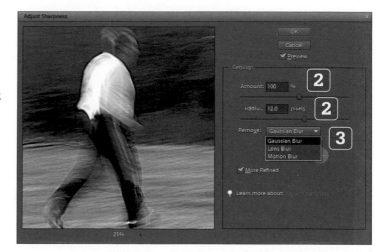

3 Beneath these settings is the Remove dropdown, with three types of blurs. What is suggested is to select the type of blur the photograph appears to have. a Gaussian Blur is the best choice for a generally blurred photograph. Lens Blur sharpens along lines of contrast. Motion Blur is used to correct a shot made with a shaky camera or a subject that would not stay still. With the Motion Blur setting, you set the angle of the blur as well.

 HOT TIP: Make repetitive small adjustments. Each sharpening adjustment builds up from the previous one. This leads to a better appearance than trying to get it all done in one strong adjustment. Another helpful approach is to make the repetitive adjustments on a sequence of layers. Each adjustment is done on a copy of the layer used for the previous adjustment. This leaves you with several steps to fall back on.

12 Repairing images

Introduction

When you consider that a photograph is a 2D representation of a 3D world, it's a wonder that so much imagery depth is kept. At times the photography process creates distortion – a bad angle, an odd sense of perspective, a crooked picture – but this can be corrected using Photoshop Elements.

Then there are the popular improvements in facials – goodbye red eye, removing blemishes, ironing out wrinkles. There is even a way to show someone's eyes to be open, despite them being shut when the photograph was taken.

Correcting camera distortion

When shooting up, down or at any angle that is not straight ahead, the photograph may have a distorted view. Photoshop Elements has a utility to correct the distortion.

1 Open a photograph that has some distorted perspective. Here is an example – the fence appears to arch inwards. In reality the fence is straight.

2 Click the Filter… Correct Camera Distortion menu item to display the Correct Camera Distortion dialogue box.

3 The Vertical Perspective slider is used to lower the perspective setting – this effectively straightens the fence. Lower the Vertical Perspective using the slider control.

The fence is now straight, but the reorientation of the image has left an empty area around the bottom half of the image. This is filled in by using the Edge Extension setting.

4 Increase the Edge Extension using the slider switch. Then click the OK button to keep the changes. The result is the image with a fence that stands straight.

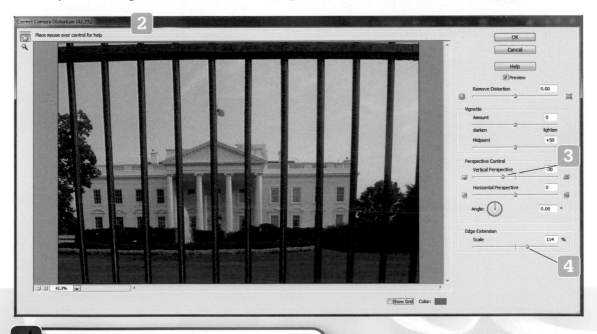

HOT TIP: In the dialogue, a screen is placed over the photograph that helps when reorienting the perspective. This screen can be turned off by unticking the Show Grid tickbox at the bottom of the dialogue.

Automatically Remove Red Eye

When light hits the retina, a colour can be reflected back that is not natural. In humans, this distortion is known as red eye (pictures of animals can result in other eye colour distortions).

1 Open a photograph that shows a face with red eye(s).

2 Click the Enhance... Auto Red Eye Fix menu item. The change is run automatically – no dialogue appears to adjust settings. In a moment the photograph is altered to show true eye colour.

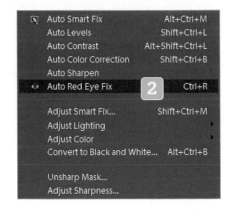

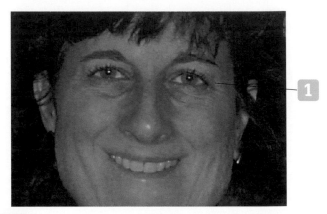

WHAT DOES THIS MEAN?

Red eye: a side effect seen in photographs in which the flash was used. The light of the flash can reflect off the eyes' retinas. It is not a natural occurrence. It appears only with flash photography.

Using the Red Eye Removal tool

The Red Eye Removal tool is great when the Auto Red Eye Fix doesn't get the job done. The Red Eye Removal tool provides adjustments so the change can be applied in the best way.

1 Open an image that has eye colour distortion. For variety, the change in this example is applied to a friendly and lovable cocker spaniel, but one whose eyes are like mirrors when a flash photo is taken.

2 Click on the Red Eye Removal tool in the Toolbox. A pair of settings appears in the tool options area.

Pupil Size: 50% ▾ Darken Amount: 50% ▾ Auto

3 The Red Eye Removal tool is used by drawing a box around the eye or just clicking on the eye. The Pupil Size percentage setting is meant to drive how much of the pupil is altered, but this is a sensitive setting. Every application of changing a pupil's colour is unique. The percentage setting alters each image in a unique way. Here, the dog's eyes have been reverted to the real colour.

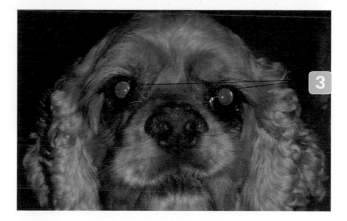

HOT TIP: When a box is drawn around the eye, instead of just clicking on the pupil, the size of the box affects the way the Pupil Size percentage affects the image. Experimentation is best to reach a happy medium.

Using the Healing Brush

The Healing Brush tool removes imperfections by applying a sampled area of the image that is similar but free of the imperfection(s). The Healing Brush is useful in both large and small images. Since it works by sampling one area to replicate in another, the important point is that the sampled and altered areas are meant to appear the same.

Here is a photograph of a sprightly young man, with a blemish (a liver spot) on his forehead. The blemish has to go. Here's how.

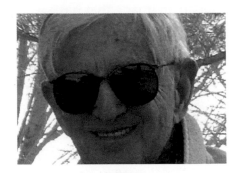

1 Right-click in the Toolbox and select the Healing Brush tool.

2 Right-click in the image to display a dialogue with an assortment of settings. In the tool options area there are other settings too.

3 After any settings are made, the tool needs to know where in the image to sample. Do this by holding down the ALT key and clicking in the image – on a part of the image that has the definition of what the corrected area should look like.

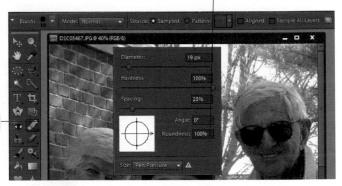

4 The Brush is moved over the blemish.

5 One click and the blemish is gone.

DID YOU KNOW?

There are various settings available with the Healing Brush and the best way to become familiar with how they work is to experiment with different settings and images.

Using the Spot Healing Brush

The Spot Healing Brush tool also removes imperfections but using a different method. Spot healing works by matching pixels that are in the bounds of the area the tool touches when used.

1 Right-click the Healing Brush tool in the Toolbox and select the Spot Healing Brush tool.

2 The tool options has two types of match methods. Each of these occurs once the area to correct is clicked on. The brush size should be larger than the area being corrected:

- Proximity Match – uses pixels around the edge of the brush area to determine a usable sample to cover the area being corrected.

- Create Texture – uses pixels within the brush area to determine a usable sample to cover the area being corrected.

In a nutshell, the methods are similar; they differ just on where the sampled pixels are used. The choice of which type to use depends on the image. Try them both to see what looks best.

3 In this example the man's wrinkles will be removed.

A brush size slightly larger than the area of the wrinkles above the eyes is selected. Then the image is clicked on the wrinkles. The wrinkles are removed.

HOT TIP: You can use a small brush size too. If so, a number of clicks and small drag-overs with the mouse are needed to complete correcting the area.

Cloning out trouble spots

Got a great shot, only to find there is something in it that doesn't belong? The Healing and Spot Healing brushes give you one way to fix this type of problem. Here is another method. This is useful for covering up large areas, but of course it all depends on what is in the image to start with. Here is a nice shot, but unfortunately someone threw some rubbish to one side of the flowers – the red circle indicates the litter.

1 Right-click on the Clone Stamp tool in the Toolbox and select the Clone Stamp tool.

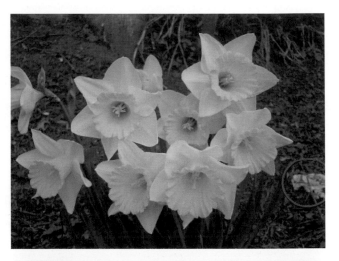

2 Looking at the place where the litter is, see if a nearby area in the photograph has the imagery that should also appear where the litter occurs. Select an appropriate brush size in the tool options area and ALT-click on the area with the correct imagery.

3 Draw over the litter. The tool clones the ALT-clicked area and overlays it on the area being drawn. Since the sample of ground is varied and choppy it blends well when drawn over the litter. The result is a clean image with no telltale distinction where the new material was drawn.

HOT TIP: Be aware of the crosshairs. As you are clone brushing, the crosshairs may move over a part of the image that should not be cloned. If this happens, undo and try sampling a different area.

Removing scratches

Scanned photographs are susceptible to imperfections appearing because of a scratched, dirty, dusty or hair-covered platen. The same could be true of the physical photograph itself. These imperfections are carried directly into the image file. Here's a way to remove a scratch.

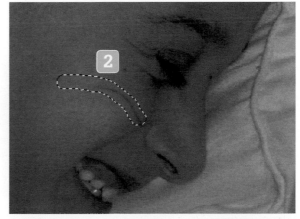

1 Open an image that has a scratch or similar imperfection.

2 Use the Selection Brush tool to draw over the scratch. The Selection Brush tool is great for creating a selection along a line.

3 Click the Filter... Noise... Dust & Scratches menu item to open the Dust & Scratches dialogue box.

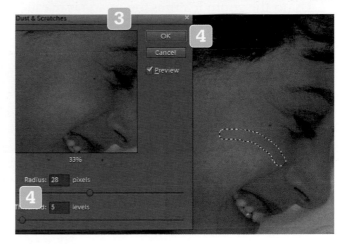

4 Adjust the Radius and Threshold while viewing the preview of the change. The Radius is a setting of how wide the affected area extends past the selection. The Threshold controls the pixel level at which the effect is applied. A lower threshold produces the effect more easily – less differentiation is needed between the selection and the surrounding area. When an acceptable balance is seen in the preview, click the OK button. Then deselect using the Select... Deselect menu.

 HOT TIP: The result of scratch removal may still leave a noticeable imperfection. Continuing with another tool, such as the Spot Healing Brush, will finish the scratch removal.

Working on pixels

The ability to zoom in and get down to the finest detail in an image lets you make the finest adjustments. The technique is to magnify greatly the image and use various tools to adjust imperfections that are best handled with changes on a few pixels.

1 Open an image with an imperfection. Here, the man's spectacles caught some glare.

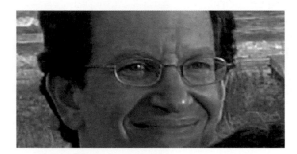

2 Using the zoom features the image is magnified and centred on the bright spot of the spectacles.

3 The technique is to change the off-colour pixels to blend in with the correctly coloured ones around them. Click on the Eyedropper tool and click on a pixel with a correct colour. This colour becomes the forecolour, as seen here in the forecolour box – on the left.

4 Next select the Brush tool and size it to 1 pixel. Click on the pixels that need colour replacement.

5 Repeat steps 3 and 4, each time using a slightly different colour (from differing pixels). At this magnification there are many similar colours spread around the surrounding pixels. When a bit of good colour variety has been put into the off-colour pixels, the result will appear as a nice blend of colour.

? DID YOU KNOW?

Working on images at the pixel level opens the door to many possibilities. The ability to alter images by the pixel is something that no other tool can do. Creativity is not hindered working at the pixel level.

Correcting a group shot

Getting people to smile, not blink, and to stay still for a few seconds can be a chore. Historically the way around this has been to take multiple shots of the same group pose. One of them has to be good, you hope. But now there's a way to take the best and combine them.

Here are shots of two people: in one shot the woman's eyes are shut and in the other shot the boy's eyes are shut.

1 Select the two images in the Project Bin.

2 Click the File… New… Photomerge Group Shot menu item. One image will appear open on the left in the active image area.

3 The other photograph is dragged from the Project Bin area and placed on the right.

4 The two images are aligned by using the Alignment Tool in the Palette Bin.

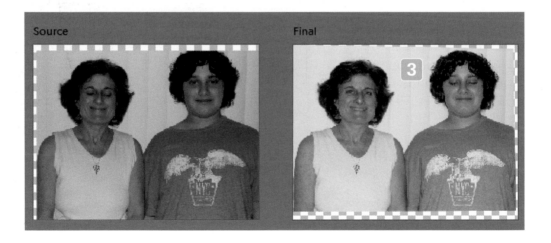

HOT TIP: The Photomerge Group Shot feature works best when merging photographs in which the subjects are sized about the same and the background is the same.

This tool works by setting three points in each image that guide how the images are to be lined up. This means that if you are replacing an eye for an eye, the eye will not accidentally end up over an ear or somewhere else. The Alignment Tool is clicked in the Palette Bin and as the mouse moves over an image three crosshairs appear. These are easily moved with the mouse and are meant to pinpoint the same features in each image.

5 Click the Align Photos button to confirm the alignment.

6 Using the Pencil Tool in the Palette Bin, draw over (or around) the areas in the image on the left that should overwrite the equivalent in the image on the right.

When all desired areas have been copied over, click the Done button in the Palette Bin. The result is the combined image: here, both people have open eyes.

? **DID YOU KNOW?**
Photomerge Group Shot can combine parts of up to 10 images.

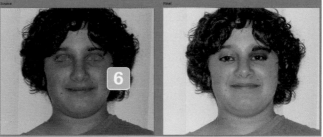

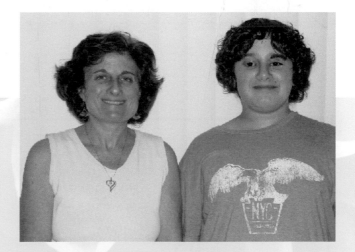

Straightening an image

It happens – you take a shot, it's great, except it's crooked. There might have been a time when such tragedies were discarded, but no more! Photoshop Elements has a utility to set it all straight.

1 Open a photograph in which the angle of view is not aligned with the edges of the image itself – in other words, crooked.

2 Select the Straighten tool from the Toolbox. Draw a line in the image, along an angle that should be the horizontal bottom edge of the image. Often there is a clear guide to do this based on the subject(s) in the image. Here, the bottom of the guitar serves as the angle to correct, so the line is drawn parallel with the guitar base.

3 The image straightens but in doing so exposes the canvas underneath. What is needed now is to crop the image. Using the Crop tool the inner part of the image is retained and is a full image itself, aligned with its edges.

 HOT TIP: An alternative straightening method is to use the Image… Rotate… Straighten menu item. Going a step further is the Image… Rotate… Straighten and Crop Image menu item. The latter straightens and crops in one automated operation.

13 Saving, printing, sending and sharing

Introduction

With all the techniques, tricks and 'ooh-aahs' you've learned and used, one thing remains to be done – get your masterpieces in front of others. Photoshop Elements helps you prepare and output your images in a variety of ways. Now it's time for family and friends to see, and even get the world to take a look – on the internet.

Saving a file in Photoshop format

There are a number of standard image file types and when an image is used on the web, in print or sent in an email message, the photograph should be in one of the standard types. Prior to that, when editing an image, Photoshop Elements will manage the file in the native Photoshop format. When saving the file, it is necessary to keep the image in the Photoshop format if there are layers. Standard formats do not support layers. When an image is saved it can be flattened into a single layer – which does allow the image to be saved in a standard format. However, if you are working on and off editing an image, then you must save it in the Photoshop format between editing sessions.

1 Click the File… Save menu item. The Save As dialogue is displayed. In the dialogue is a dropdown of file types. Select Photoshop (*.PSD).

2 There are a couple of key options in the dialogue. If you wish to have the image available for view in the Organizer, tick the Include in the Elements Organizer tickbox. If your image has layers, tick the Layers tickbox.

3 Navigate to the folder where the image should be saved and click the Save button.

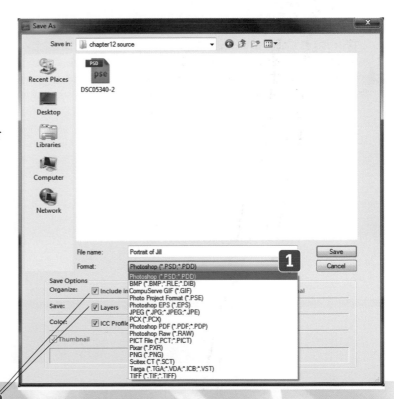

HOT TIP: You must keep the Layers tickbox ticked to avoid flattening the layers into a single one.

Saving a file in a standard image format

Saving an image file in a standard format is necessary to enable the file to work in any application or place where Photoshop format files are not recognised. The most popular of these formats is the JPEG format, as most images on the web are of this type. Other popular types are GIF, TIFF and PNG.

1 If the image contains layers they must be flattened into a single background. Click on the Layers… Flatten Image menu item.

2 Click the File… Save menu item. The Save As dialogue is displayed. Select JPEG as the format.

3 Navigate to the folder where the image should be saved and click the Save button. The JPEG Options dialogue box opens.

4 Make any appropriate selections and click OK.

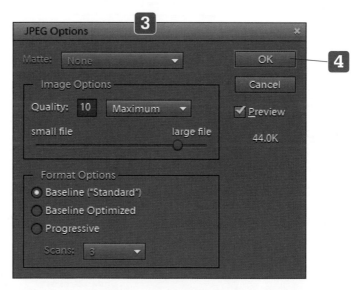

HOT TIP: The various file types each have their own set of properties. For example, saving in the GIF format displays a dialogue about colour options.

DID YOU KNOW? Format is synonymous with 'file type'.

Saving for the web

The number one consideration for images on the web is file size. This applies both to the physical size and the file size in bytes. The physical size matters because the image takes up space on a web page. The file size matters because it affects how fast a web page is loaded.

1 Click the File… Save For Web menu item. The Save For Web dialogue is displayed.

The dialogue has two panes – the before and after. On the left is the image in its current format, and the right pane shows what it will look like based on selections made in the dialogue.

2 Reduce the size of the image and click the Apply button. Select the output file format. An image for the web should not be exceedingly large. It is not unreasonable to reduce the image by a large percentage.

3 Click the OK button. The Save Optimized As dialogue opens. This is a typical Save dialogue. Navigate to the folder of your choice and click the Save button.

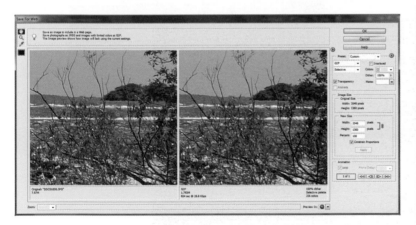

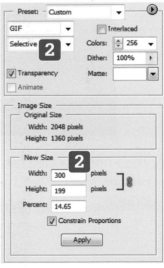

 HOT TIP: Leave the Constrain Proportions tickbox ticked. This ensures that changing any single size attribute – the width, height or percentage – forces the other attributes to adjust accordingly. Bottom line – the image will retain its appearance, just resized. There will be no squeeze or stretch in the adjustment.

Printing a photograph

Most people have colour printers. Printing a photograph in colour is an obvious choice.

1 Click the File... Print menu item to display the Print dialogue.

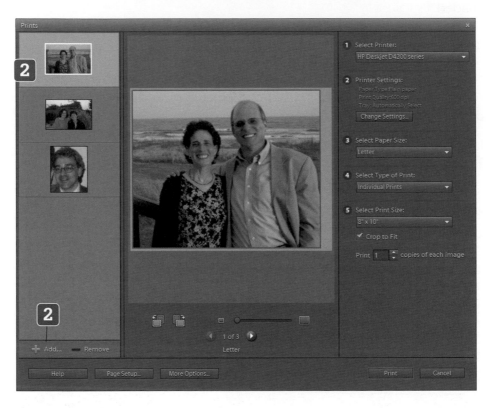

2 The Print dialogue has many settings. The left side has a thumbnail image of the output. You can add additional photographs to be printed by clicking the Add button.

3 In the middle of the dialogue is a preview in which you can flip the image and also zoom in and out using the slider switch. When multiple photographs are selected for printing, you can cycle them in the preview.

4 The right side of the dialogue offers further options. Here you select the printer, paper size, number of copies to print and other settings. When finished click the Print button.

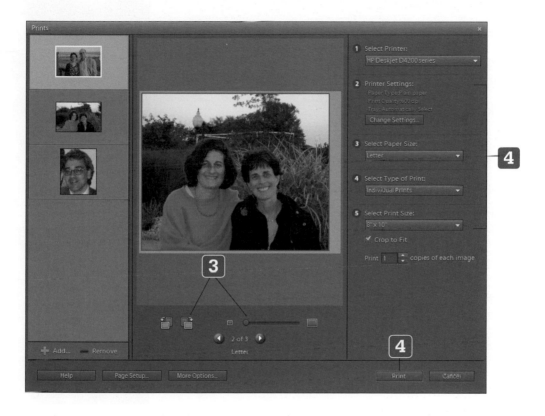

 HOT TIP: If you feel the need to print an image during editing – to see how it looks on paper – it's beneficial to print it at a small size to save ink.

Emailing photographs

The email function in Photoshop Elements offers two methods – embed the photographs in the body of the email or attach the files. This describes the steps for the former.

1 In the Organizer, click the Share tab.

2 Click the Photo Mail button.

3 Drag images from the Organizer into the Photo Mail pane.

4 Click the Next button.

5 The next screen is where you compose a message for the email and select recipients.

6 Type your message in the dialogue box. If no recipients are listed, or you wish to add additional recipients, click the icon of a person to the right of the Select Recipients label.

7 The Contact Book dialogue opens. In here, you can enter, edit and delete contacts. Click the OK or Cancel button to close the Contact Book.

 HOT TIP: You can use the plus and minus symbols to add or remove images.

8 Click the Next button. The Stationery & Layouts Wizard dialogue opens.

This two-step dialogue lets you customise the appearance of the images by inserting a background, borders, a caption and a layout. When finished with these selections, click the Next button on the second wizard screen.

9 An email message is created in your computer's email program and is ready to be sent.

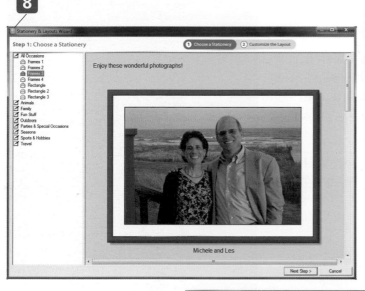

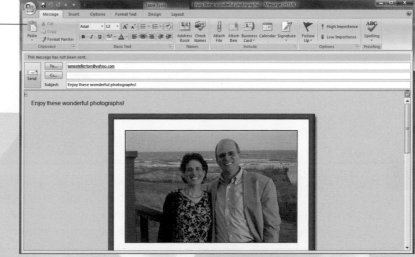

Share to Facebook

Your favourite photographs can be uploaded to your Facebook account. What a timesaver!

1 In the Organizer, select some photographs to assemble into an album, or select an album you have already made (see pages 37 and 38).

2 Click the Share tab.

3 Click the Share to Facebook button. Photoshop Elements will display a dialogue requesting your authorisation.

4 Your default browser will open to the Facebook login page. Log in to your account.

5 Return to Photoshop Elements which is still running on your computer. A dialogue now requests that you click to complete the authorisation.

6 The Share to Facebook dialogue opens. Here you select to add the photographs to an existing Facebook album or to create a new one. There is also the choice of who is allowed to see the album. Click the Upload button.

7 When finished, the dialogue reports the success of the upload and provides a button to go to your Facebook account.

8 The album is now part of your Facebook account.

 HOT TIP: You must limit which photographs are to be uploaded. If you start the Share to Facebook process without first selecting photographs or selecting an album, Photoshop Elements will prompt you to confirm if you mean to upload all your photographs. This is not recommended! You may have hundreds or thousands of photographs in the Organizer!

Creating a Photo Book

A Photo Book is an assembled set of photographs, organised into a formatted album. The Photo Book can be created and then ordered via Adobe Photoshop Services.

1 In the Editor, if no images are in the Project Bin, then open several images.

2 Click the Create tab, then click the Photo Book button. Rearrange the images in the Project Bin so the first is the one you want to be on the title page. You can drag the images in the Project Bin with the mouse. The first image appears in the Create pane as the Title Page photo.

3 In the Photo Book dialogue select a size and a theme. Note that in the Sizes pane there are online services, and the option to print locally (to your printer). Tick the Autofill with Selected Images option.

4 Click the OK button. Photoshop Elements creates the Photo Book. The process may take several minutes. When the process is complete you can make further refinements such as changing the layout, frame, and more.

5 Save the Photo Book as a file by using the File … Save menu. Save as a PDF file if finished with creating the book. Save in the Photo Project Format if you plan to work further on the Photo Book.

6 Click the Done or Print button.

HOT TIP: If you select the Choose Photo Layout option, then on this screen you select the layout, and on an additional screen you select the theme and the number of pages.

Creating a slide show

A great attention grabber is the slide show. Besides its thematic appeal, the use of transitions between slides is always a crowd pleaser.

1 In the Organizer, select an album with a reasonable number of images. Click the Create tab.

2 Click the Slide Show button. The Slide Show Preferences dialogue is displayed.

3 Select the Static Duration, Transition type, Transition Duration and any other desired settings. Click the OK button. The Slide Show Editor is displayed.

In this dialogue more properties can be set for the slide show. Here you can select a different transition between each slide, reorder the slides, add slides, and more. Using the VCR buttons you can preview the slide show.

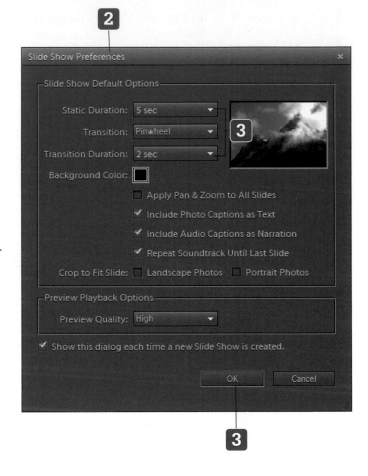

2

Slide Show Preferences ✕

Slide Show Default Options

Static Duration: 5 sec ▼

Transition: Pinwheel ▼ **3**

Transition Duration: 2 sec ▼

Background Color: ■

☐ Apply Pan & Zoom to All Slides

✔ Include Photo Captions as Text

✔ Include Audio Captions as Narration

✔ Repeat Soundtrack Until Last Slide

Crop to Fit Slide: ☐ Landscape Photos ☐ Portrait Photos

Preview Playback Options

Preview Quality: High ▼

✔ Show this dialog each time a new Slide Show is created.

OK Cancel

3

4 When finished editing, click the Save Project button in the upper left corner of the dialogue. The project is saved in the Organizer, with the current date.

HOT TIP: How many images should you include? Ask yourself how many images you would wish to see of someone else's photographs. Consider the attention span of your intended audience.

5 With the Slide Show Editor still open, click the Output button. A set of save options is presented in the Slide Show Output dialogue box.

6 Make the appropriate selections and click the OK button.

7 A standard Save dialogue opens, letting you navigate to the folder where the slide show should be saved. When done, click the Save button.

Creating a collage

A collage is a grouping of photographs for the pleasant artistic effect.

1 In the Editor, click the Create tab.

2 Click the Photo Collage button.

3 Select the size in the Photo Collage dialogue. Tick the Autofill with Selected Images option.

4 Click the OK button. Photoshop Elements assembles the collage. Photographs from the Project Bin are placed in the collage.

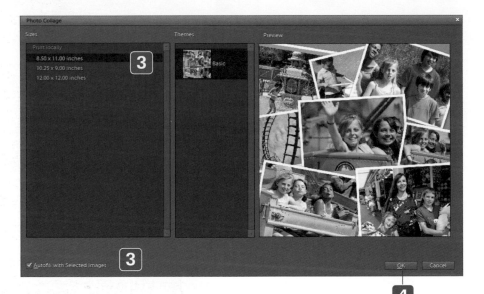

HOT TIP: You can replace the images by dragging new images into the collage. You can use the mouse to change the placement and size of the images.

Creating an Online Album

An online album is meant for the web. If you have access to a website, here is a way to get your photographs available to one and all.

1 In the Organizer, click the Share tab.

2 Click the Online Album button. Existing albums are displayed. There is also a choice to create a new album. These steps show how to use an existing album.

3 Click on the desired album.

4 Select where to share to.

5 Click the Next button. In the next screen make any appropriate choices, such as which template to use. Select a category and a template. The template updates when a category is selected.

? DID YOU KNOW?

If you saved the album to a CD, DVD, or to the hard disk of your computer, use a File Transfer Protocol (FTP) program to move it to your web server.

6 If necessary, enter a folder name, and browse to a directory in which to save the folder.

7 Click the Done button. The Online Album is created as a folder in the directory you selected.

HOT TIP: If you know how to use FTP, enter the settings and upload the album! If FTP is a mystery, maybe there's a neighbourhood tech lover or a clever relative to help.

Top 10 Photoshop Elements Problems Solved

Problem 1: The colours don't look good in this photograph

Photoshop Elements can enhance an image to have the best colour range and balance.

1 Click the Enhance... Auto Color Correction menu item.

2 The photograph is corrected according to built-in methods. In this example the colours appear brighter and fuller.

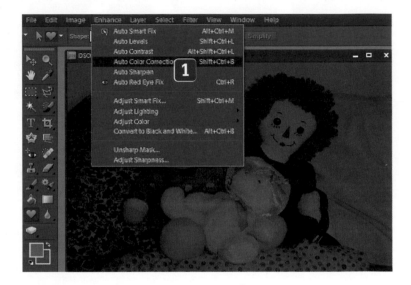

HOT TIP: If an area of an image has been 'selected', the correction will be applied to just the selected area. Creating and using selections is covered in Chapter 5.

Problem 2: How do I select the foreground and background colours?

Some photo editing work involves directly adding colour as if painting it into the photograph with a brush. But before painting, how do you select the colour?

Below the Toolbox are the colour indicators. These appear as one box overlapping the other: the top box shows the foreground colour and the bottom one shows the background colour. The use of foreground and background colours depends on the image change that is being done. Some changes require a setting for both colours – such as the colour of text on a background of a different colour. Other colour change operations may need just one of the colours.

To change a colour, simply click on it, which opens up the Color Picker dialogue.

In the dialogue you can select the colour by moving the mouse around in the large colour box, along with moving the mouse up or down in the vertical colour bar. The large box is a blend of the brightness and saturation, and the vertical bar is the hue. Alternatively you can enter known values:

1 The three settings for hue, saturation and brightness.

2 The three RGB values for red, green and blue.

3 The hexadecimal number for the colour (used in web page settings).

 HOT TIP: You can quickly swap the colours by clicking on the small two-way arrow to the upper right of the two boxes.

Problem 3: There is too much extra space and unwanted things in this photograph

Sometimes a golden moment presents itself and you run for the camera and click away. While you catch those beautiful shots, you can also get some annoying or distracting items in the photograph. This is what cropping is for. Here is a photograph of a rainbow, along with the undesirable spotlights at the top left. Those spotlights must be removed.

1 Click on the Crop tool in the Toolbox.

2 Drag the mouse in the image to create a line between what to keep and what to discard. The mouse pointer looks like the crop tool while doing this.

3 When the mouse button is released a preview of what the image will look like appears. Just below it are Commit and Cancel icons.

4 Clicking the Commit icon (the tickmark) displays the updated image.

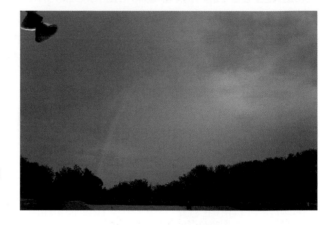

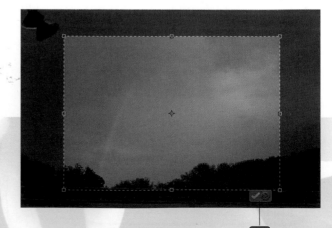

Problem 4: I'm using the Type tool to enter text but it just keeps going right past the image!

When entering text, the text will continue in a line, even past the image area! There are two ways around this. One is to press the Return key while you type. Better, though, is to have the text wrap to dimensions that you create.

1 Click the Type tool and instead of clicking where the typing should begin, drag the mouse. A bounding box will appear.

2 Type away! As you type the text will wrap to the dimensions of the box.

3 The dimensions can be changed by using the handles around the edge of the box.

4 Click the Type tool to remove the appearance of the box. The text will stay in place.

I am the text that is inside a box. The box keeps me wrapped up like this. I like the way this works. I don't worry about running out of image area. **2**

I am the text that is inside a box. The box keeps me wrapped up like this. I like the way this works. I don't worry about running out of image area. **3**

Problem 5: Yikes, my photo came out blurry!

Photoshop Elements provides a handy enough utility to get a good crack at improving a blurry image.

1 Click the Enhance... Adjust Sharpness menu item to display the Adjust Sharpness dialogue box.

2 In the dialogue are settings for the amount of 'unblur' to apply, and the radius – the width of pixels used to calculate how the effect is applied.

3 Beneath these settings is the Remove dropdown, with three types of blurs. Gaussian Blur is the best choice for a generally blurred photograph. Lens Blur sharpens along lines of contrast. Motion Blur is used to correct a shot made with a shaky camera or a subject that would not stay still.

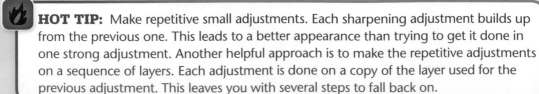

HOT TIP: Make repetitive small adjustments. Each sharpening adjustment builds up from the previous one. This leads to a better appearance than trying to get it done in one strong adjustment. Another helpful approach is to make the repetitive adjustments on a sequence of layers. Each adjustment is done on a copy of the layer used for the previous adjustment. This leaves you with several steps to fall back on.

Problem 6: Aunt Sally has red eyes!

When light hits the retina, a colour can be reflected back that is not natural. In humans, this distortion is known as red eye (pictures of animals can result in other eye colour distortions).

1 Open a photograph that shows a face with red eye(s).

2 Click the Enhance... Auto Red Eye Fix menu item. The change is run automatically – no dialogue appears to adjust settings. In a moment the photograph is altered to show true eye colour.

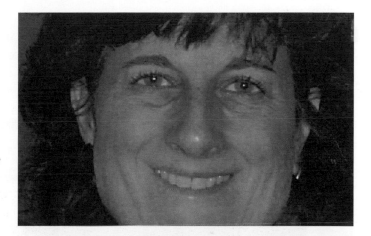

? DID YOU KNOW?
Your camera may have a feature that removes red eye when the photograph is being taken.

Problem 7: The subject in the photograph seems warped

When shooting up, or down, or at any angle that is not straight ahead, the photograph may have a distorted view. Cameras try to capture the image in the best way, but that is where 2D can confuse a 3D reality. Photoshop Elements has a utility to correct the distortion.

1 Open a photograph that has some distorted perspective. Here is an example – the fence appears to arch inwards. In reality the fence is straight.

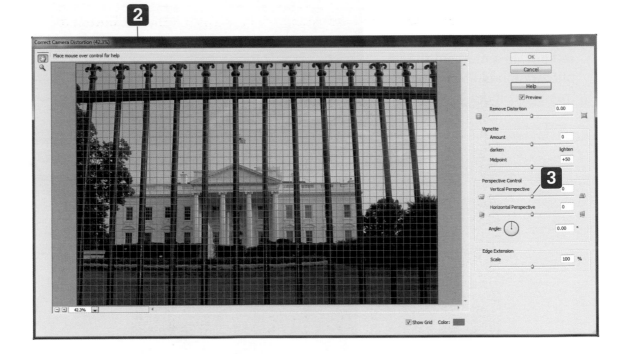

 HOT TIP: In the dialogue, a screen is placed over the photograph that helps when reorienting the perspective. This screen can be turned off by unticking the Show Grid tickbox at the bottom of the dialogue.

2 Click the Filter… Correct Camera Distortion menu item to display the Correct Camera Distortion dialogue box.

The dialogue has controls to correct the perspective vertically and horizontally, to correct if the perspective distortion is one of a bowing in or out, or if the perspective is based on lighting differences around the edge of the image. In this example, it's the vertical perspective that needs correction. The Vertical Perspective slider is used to lower the perspective setting – this effectively straightens the fence.

3 Lower the Vertical Perspective using the slider control.

The fence is now straight, but the reorientation of the image has left an empty area around the bottom half of the image. This is filled in by using the Edge Extension setting.

4 Increase the Edge Extension using the slider switch. Then click the OK button to keep the changes. The result is the image with a fence that stands straight.

Problem 8: How can I get rid of skin imperfections?

The Spot Healing Brush removes imperfections by matching pixels that are in the bounds of the area the tool touches when used.

1 Right-click the Healing Brush Tool on the Toolbox and select the Spot Healing Brush Tool.

2 The tool options are two types of match methods. Each of these occurs once the area to correct is clicked on. The brush size should be larger than the area being corrected:

- Proximity Match – uses pixels around the edge of the brush area to determine a usable sample to cover the area being corrected.

- Create Texture – uses pixels within the brush area to determine a usable sample to cover the area being corrected.

The choice of which type to use depends on the image. Try them both to see what looks best.

3 In this example the man's wrinkles will be removed.

A brush size slightly larger than the area of the wrinkles above the eyes is selected. Then the image is clicked on the wrinkles. The wrinkles are removed.

 HOT TIP: You can use a small brush size too. If so, a number of clicks and small drag-overs with the mouse are needed to complete correcting the area.

Problem 9: My scanned-in photograph has a scratch. How can I remove it?

Scanned photographs are susceptible to imperfections appearing because of a scratched, dirty, dusty or hair-covered platen. The same could be true of the physical photograph itself. These imperfections are carried directly into the image file. Here's a way to remove a scratch.

1 Open an image that has a scratch or similar imperfection.

2 Use the Selection Brush tool to draw over the scratch. The Selection Brush tool is great for creating a selection along a line.

3 Click the Filter... Noise... Dust & Scratches menu item to open the Dust & Scratches dialogue box.

4 Adjust the Radius and Threshold while viewing the preview of the change. The radius is a setting of how wide the affected area extends past the selection. The Threshold controls the pixel level at which the effect is applied. A lower threshold produces the effect more easily – less differentiation is needed between the selection and the surrounding area. When an acceptable balance is seen in the preview, click the OK button. Then deselect using the Select... Deselect menu.

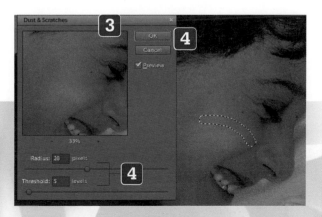

HOT TIP: The result of scratch removal may still leave a noticeable imperfection. Continuing with another tool, such as the Spot Healing Brush, will finish the scratch removal.

Problem 10: The photo came out crooked, now what?

It happens – you take a shot, it's great, except, it's crooked. There might have been a time when such tragedies were discarded, but no more! Photoshop Elements has a utility to set it all straight.

1 Open a photograph in which the angle of view is not aligned with the edges of the image itself – in other words, crooked.

2 Select the Straighten tool from the Toolbox. Draw a line in the image, along an angle that should be the horizontal bottom edge of the image. Often there is a clear guide to do this based on the subject(s) in the image. Here, the bottom of the guitar serves as the angle to correct, so the line is drawn parallel with the guitar base.

3 The image straightens but in doing so exposes the canvas underneath. What is needed now is to crop the image. Using the Crop tool the inner part of the image is retained and is a full image itself, aligned with its edges.

 HOT TIP: An alternative straightening method is to use the Image… Rotate… Straighten menu item. Going a step further is the Image… Rotate… Straighten & Crop Image menu item. The latter straightens and crops in one automated operation.

Use your computer with confidence

Office 2010

9780273736127

Excel 2010

9780273736134

Word 2010

9780273736141

Powerpoint 2010

9780273736158

Windows 7

9780273729136

Excel 2007

9780273723547

Office 2007

9780273723554

Laptop Basics
Windows 7 Edition

9780273736806

Computer Basics
Windows 7 edition

9780273736844

iPad

9780273744139

Mac Basics

9780273729297

Digital
Photography

9780273723516

Editing, Storing &
Sharing Digital Photos

9780273744146

Photoshop
CS5

9780273736820

Build your
First Website

9780273745419

Web Design

9780273723530

Netbook
Basics

9780273734925

Windows 7
for the Over 50s

9780273729181

Laptop Basics
for the Over 50s

9780273729129

Computer Basics
for the Over 50s

9780273729174

in Simple steps

Practical. Simple. Fast.

PEARSON